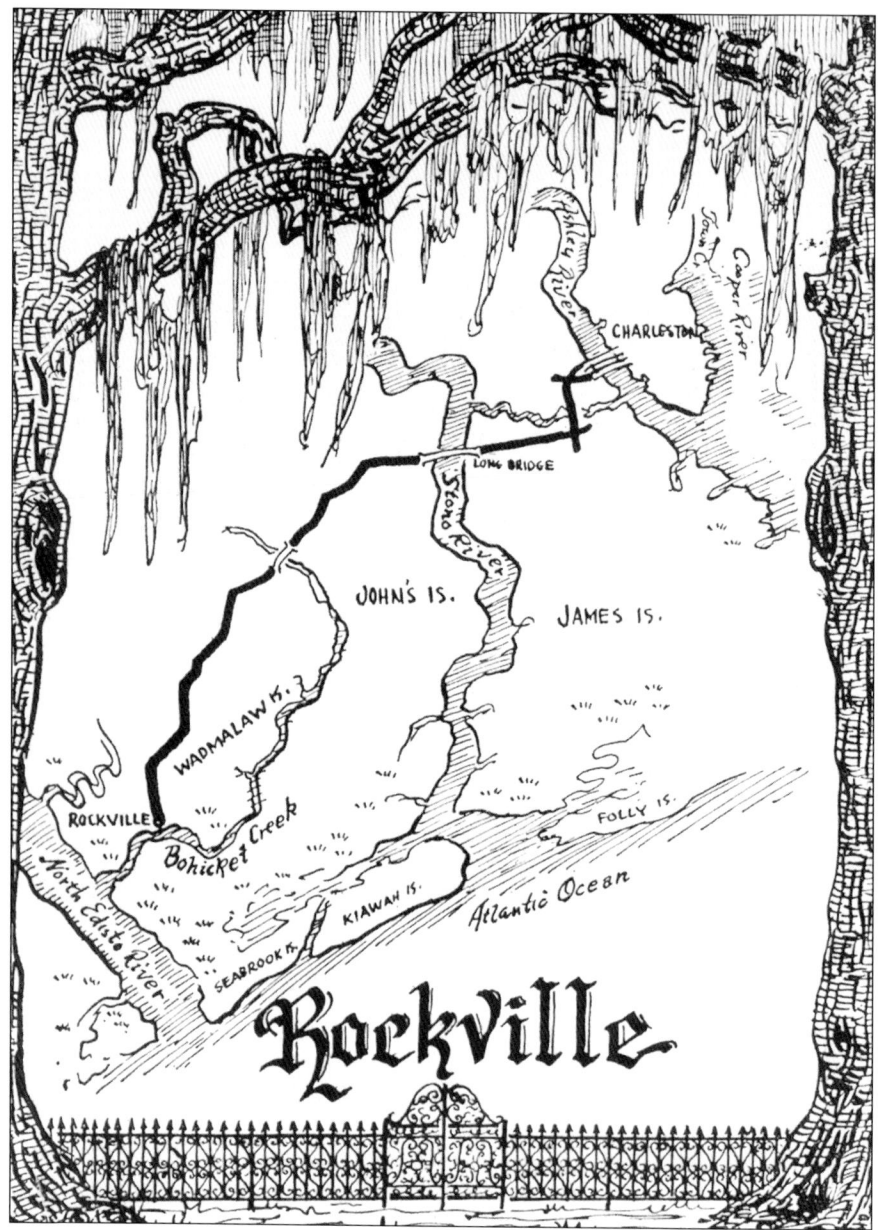

ROCKVILLE. This was the cover of the printed version of a 1957 Wadmalaw Island PTA speech on the history of Rockville, South Carolina, that Sophia Augusta Seabrook Jenkins wrote. Many people wanted copies of her speech, so she self-published it with the help of her mother, Mary Caroline Sosnowski Seabrook. When more people wanted copies, she had 50 or so professionally printed and publicly sold them for $1. Joseph D. Rivers may have drawn this cover because he drew the designs on the large Seabrook family chart that was created in 1963.

On the Cover: THE 1937 ROCKVILLE REGATTA. The photograph on the cover was taken by M. Paine while he was on the bluff edge of Bohicket Creek. The committeemen standing beside the starting post are watching the Class A and B sailboats begin their race. (Photograph courtesy of Dellie Eaton.)

Alicia "Lish" Anderson Thompson

Best wishes,
Lish Thompson

Copyright © 2006 by Alicia "Lish" Anderson Thompson
ISBN 0-7385-4234-2

Published by Arcadia Publishing
Charleston SC, Chicago IL, Portsmouth NH, San Francisco CA

Printed in Great Britain

Library of Congress Catalog Card Number: 2005934873

For all general information contact Arcadia Publishing at:
Telephone 843-853-2070
Fax 843-853-0044
E-mail sales@arcadiapublishing.com
For customer service and orders:
Toll-Free 1-888-313-2665

Visit us on the Internet at www.arcadiapublishing.com

This pictorial history is dedicated to my great-aunt, Sophia Augusta Seabrook Jenkins, for her lifelong dedication to collecting Sea Island history, genealogies, and family photographs.

Contents

Acknowledgments	6
Introduction	7
1. The Planters and Their Summer Homes	9
2. Grace Chapel and the Rockville Presbyterian Church	65
3. The Villagers and Their Way of Life	81
4. The Rockville Races and the Sailors	113
Index	127

Acknowledgments

I give thanks to the ladies of my mother's paternal ancestry, who left behind numerous letters, notes, and photographs that pertained to the village of Rockville. My great-aunt Sophia "Sophie" Augusta Seabrook Jenkins often corresponded with relatives, accumulated much information on island families, and shared it with numerous genealogists. I have been researching the history of Rockville since 1993, and this book would not have been possible had it not been for her careful preservation of the past. I have tried to be as accurate as possible in relaying this information.

Thanks to my colleague, Harlan Greene, who obtained for the library Elias Ball Bull's historical surveys and applications for the National Register of Historic Places Inventory of Charleston County's historic properties. The house information on Rockville was compiled in the 1970s and has been an invaluable resource for this book. Harlan also helped me obtain a grant from the Charleston Scientific and Cultural Education Fund, which was established under the will of Charles Hughes.

Many thanks to my "cousins," Sandiford Bee, Dellie Stevens Eaton, Kathie Seabrook Jordan, Emily Jenkins Leland, and Jean Hills Townsend, who loaned me their well-labeled personal family photographs and scrapbooks. Annabeth Proctor was a great help to me in finding information, photographs, and family genealogies, and she gave me a personal perspective of village life, since her husband, Donald, and his brother, Steve, grew up there.

At this point, I would like to recognize Babs Ambrose; Bissell, James, and Edward Anderson; Helen Bailey; Patsy Bailey; Rose Balis; Annie Manson Jenkins Batson for her stories; Rosie and Sandy Bee; Martha Bingman; Kate McChesney Bolls for her book, *The Daniel Townsends of the SC Islands*; Anne Bridgers; Mary Elizabeth McChesney Buskovitch; Nic Butler; Russell and Lara Byrd, Kevin Corcoran and Katie Gray for caring for our two canine children; Bobbie Carlson; Henry Cauthen; Marianne Cawley; W. T. Crane; Mike Dusenbery; Jessie Ezell; Adam Ferrell; Peggy Gale; Ken Gibert; Ernest Grimball; Amanda Holling; Timothy Hughes; Edward "Ned" LaRoche Jenkins; Monica Langley; Dubose and Nick Lindsay; Christine Lloyd; Ella Heyward Palmer; Margaret and Robert Madsen; Julia Blanche Townsend McChesney for her book, *Crazy Patch Work Quilt*; Ethel Seabrook Nepveux; Liz Newcombe; M. Paine for his photographs; Nancy Peeples; Steven Profit; Amy Quesenbery; Walter Rhett; Joseph L. Rivers for his book, *Seven South Carolina Low Country Families*; Don Rutledge, William and Katherine Seabrook; Mary Agnes Seabrook; Margaret and Oliver Francis Seabrook; Jill Snider; Snowden Yates; Marianne Seabrook Stein; Kay Terrell; Lois Thompson; Mary Townsend; Gaillard F. S. Waterfall; Sally Whaley; Katherine Williams; Mary E. Wood; Carol Woody; Connie Wyrick; Alice Anderson Yates; and *all* of my family and my friends in the Charleston County Public Library system and at St. Michael's Episcopal Church for their help, advice, and encouragement.

Finally I want to thank my wonderfully supportive husband, Fred Thompson, and my mother, Alicia Palmer Seabrook Anderson, who have been very helpful during my research. With all of this information and help at hand, I have easily been able to find words and pictures for this photographic history. But my mother's advice has been the most valuable to me, for she has been my main link to the past.

Introduction

Nestled on South Carolina's Sea Islands and southern coastal regions, picturesque villages lie within reach of winding saltwater tidal creeks. Each of these quaint villages has its own unique history, but all share similarities in design and function. The early tenants were affluent plantation owners who attempted to alleviate the oppressive summer heat by constructing houses with large porches high off the ground on tabby foundations, whose features maximized the circulation of the prevalent sea breezes. Unfortunately the planters found that the hot summer months were unbearable on their new plantations, so they sought to build seaside dwellings in hopes of escaping the heat and the dreaded deadly "miasma," known to us today as swamp fever or malaria.

More planters followed suit, and soon small settlements developed, which were found to be in close proximity to their plantations. The villagers had all the benefits of home, for they would pack up all of their furniture, children, pets, and livestock each summer and move them to their summer homes. Not only was summer the time of harvesting fresh fruits and vegetables, but also there was an abundance of seafood in the creeks for everyone's enjoyment such as spot tail bass, flounder, and trout; white and brown shrimp; and crabs and oysters.

On October 30, 1629, England's King Charles I issued a charter for the lands of southeastern North America. In his honor, it was called "Carolana," which is Latin for "land of Charles" and was delivered among eight Lord Proprietors. On June 23, 1666, in the presence of his ship's crew and Edisto Island Indians, Lt. Col. Robert Sandford claimed, at a site near Rockville, the lands south of Virginia, north of Florida, and east of the Pacific Ocean and ceremoniously named them "Carolina" in honor of his benevolent king's son, King Charles II and his lords.

The actual history of the village of Rockville begins with a man named Paul Hamilton. In 1736, Hamilton received a 1,060-acre land grant from King George II of England for the area later known as "The Rocks" or "Rocks Plantation." This name was derived from the fact that large iron ore deposits, which run underneath the entire island of Wadmalaw, cropped out along the bluff edge at Rockville.

By the year 1835, a small grid-work of houses, churches, and roads had developed along Rockville's front creek and bluff edge. Sixteen of the buildings are on the National Register with the oldest one possibly being built before 1776 as a ferry house or tavern. Most of these summerhouses have various historical and architectural features with similar, basic floor plans. A main meeting hall was originally built in a central, vacant, oak-covered, grassy pasture called the Green. It was later rebuilt on a man-made lot on the western point of the village on Breakfast Creek, and is now known as the Sea Island Yacht Club.

The villagers found that it was often very difficult to attend their inland churches while residing in the village, so the men built an Anglican chapel-of-ease and, later, a Presbyterian church. They were not similar in design, but they both did aid and assist each other when one or the other was damaged or when only one minister could be had for Sunday services. Both congregations being Protestant enabled the parishioners to easily adapt to each other's worship practices.

As the years continued and the village grew, areas inside and immediately outside Rockville's property lines were referred to by special names such as Towns End and Brigger Hill. The area where the Townsend houses were located, and Rocklands on the western side, were part of Dr. Jenkins Daniel Townsend's plantation. The higher, more northern part of the village was called High Cherry Hill. Cherry Hill and Roseville encompass the land to the northeast, and Cherry Point was the most eastern part of the village. Wild cherry and plum trees grew in all of these areas, and it has been told that "Buster" Whaley planted the pecan trees at Cherry Point. Rockfarm and Rock Place were located at the most northern part of the village where the portion of the black cemetery is located.

The large navigable waterway that flows along Rockville's southern edge is called Bohicket Creek, and it once provided the only means of transportation for people, crops, and mail. Adams Creek and Breakfast Creek border the village to the west, and there is an unnamed creek on the eastern side. The islanders used flat-bottomed ferryboats that docked at a central wharf to travel to and from other Sea Islands and to the city of Charleston. The island residents enjoyed sailing homemade boats and often raced them against each other.

The idea of the Rockville Regatta dates back to the pre-Colonial days of the Native American canoe races. The Native Americans were thought to use the creek's natural course for canoe racing, and like the natives, after the summer's harvest, the men could be found in their yards shaping, scraping, and painting their homemade creations for the competitive rivalry that would ensue at the end of each summer. The first written report of a well-attended sailboat race on Bohicket Creek was by the Reverend John Cornish in his diary on August 20, 1842. It is not known exactly when these races started or how long they lasted concurrently after this noted race, but in August 1890, an annual sailing event began among the planters and was thereafter called the Rockville Regatta.

The village of Rockville has weathered the storms of man and nature and yet has remarkably remained the same. It became a town almost a decade ago on July 1, 1996, and currently has approximately 150 residents. The people who have loved her have sustained the village's beauty throughout her 170 years. Her friendly, earthen paths paved with white broken oyster shells transport us back to the days of a serene slow-moving lifestyle. Visitors should appreciate her graciousness and majestic beauty while still respecting her private soul. There are neither tourist attractions nor accommodating facilities for the public in this village, and the only souvenirs that can be acquired are the colored images one records in the mind or through the eye of a camera.

One

THE PLANTERS AND THEIR SUMMER HOMES

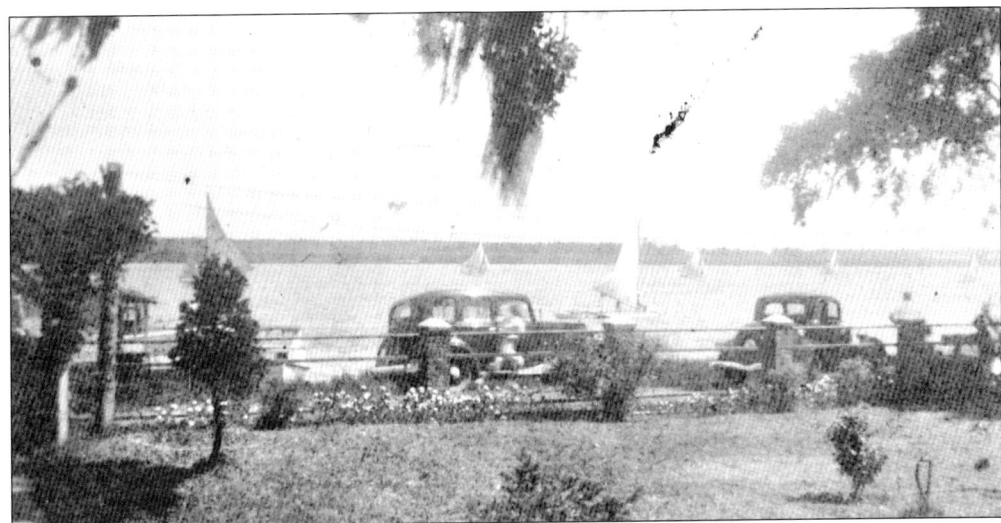

ROCKVILLE'S FRONT STREET. By 1824, the first row of one-acre lots was established along the bluff edge of Bohicket Creek by Benjamin Adams. The houses faced the creek but were separated from it by a dirt road called Front Street. The village plan included a community acre of green space used for recreation and relaxation. A plan for a second row of houses, which included two churches, developed around 1828. Two-sided dirt streets connected the eastern side to the western side of Rockville, which was divided by "The Road to Rockville," also known as Maybank Highway. These roads have assumed the names Sea Island Yacht Club and Grace Chapel Roads. Another dirt road called Welsh Lane led from the Townsend's Overseer's House, at the back of the village, past the Rockville Presbyterian Church and Bailey's Store to Bohicket Creek. By 1835, William Seabrook of Edisto had completed the layout of the houses, constructed a permanent landing for his Edisto Island Ferry Company, and insured lots in the village for his 10 children. (Photograph courtesy of Emily Jenkins Leland.)

GEORGE WASHINGTON SEABROOK. "Washington," as he was known, was the third son of William Seabrook of Edisto and his first wife, Mary Ann Mikell. Washington was born on Edisto Island on January 14, 1808, married Martha Abigail Clark on January 12, 1830, had 12 children, and died on June 22, 1866. He was educated at Princeton and planted Sea Island cotton on Edisto and Seabrook Islands. He signed the Ordinance of Secession in Institution Hall on the evening of December 20, 1860. Six generations of Seabrooks have had sons named George Washington.

DORA AND JOHN SOSNOWSKI. Pictured here are Grace Eudora "Dora" Sosnowski, who was born on June 9, 1894, and her brother, John F. Sosnowski Jr, who was born on November 3, 1896. Dora married George Washington Seabrook Jr. in 1919, and they had two children, Eudora Sosnowski Seabrook and George Washington Seabrook III. Eudora married William Earl Fowler, and George III married Phillis Farquear. John married Eliza Fisk Skinner and had two children, Dr. John Richard and Rev. Frederick Sosnowski.

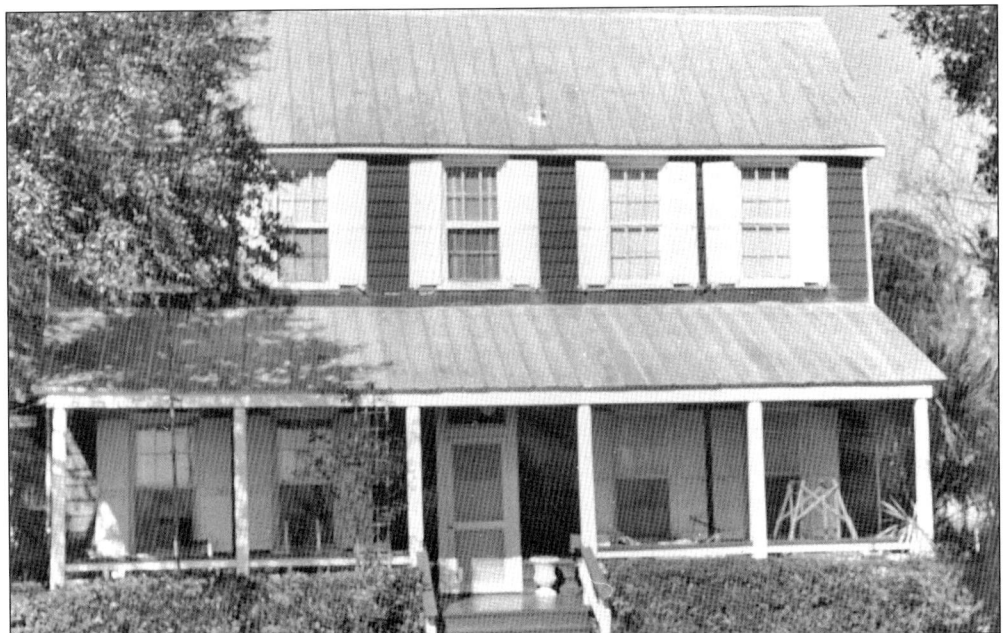

JOHN FERRARS SOSNOWSKI. John and his wife, Lena Washington LaRoche Sosnowski, owned a small, red-stained, two-story house at the eastern end of the village. This wooden cottage was built for George Washington Seabrook about 1897. John allowed his daughter, Grace Eudora Sosnowski, and her husband, George Washington Seabrook, to live in the house. (Photograph by Elias B. Bull; courtesy of Charleston County Public Library.)

THE JOHN FERRARS SOSNOWSKI HOUSE. Historical survey writer Elias B. Bull wrote, "This well-built, attractive, little, late nineteenth century, plantation summerhouse is admirably suited to the large lot it occupies. Since it was built on the waterfront where it can get all the breezes there was no need to elevate it high off the ground. The style of architecture is typical of the rest of the houses in the Rockville Historical District. It is undoubtedly the best of the late 1800's summerhouses in Rockville." (Photograph by Elias B. Bull; courtesy of Charleston County Public Library.)

HENRY BAILEY WHALEY. This house was built about 1897. Henry was born in 1872, married Florence Legare Seabrook Whaley, and had three children, an infant who died at birth, Gladys Leola, and Ephraim Clark "Buster" Whaley. Henry was buried at St. John's Episcopal Church on John's Island on May 31, 1928. (Photograph by Elias B. Bull; courtesy of Charleston County Public Library.)

THE HENRY BAILEY WHALEY HOUSE. Historian Elias B. Bull wrote, "This wooden building originally was rectangular in shape and consisted of a central hall with two pairs of rooms, one pair to a side. Since then a small extension has been added to the building to the left or western side and another room plus a side porch to the right or eastern side. As it stands today, the most interesting feature is the shed dormer, which, upon first glance, gives an impression of being a bona fide second story. The basic rectangular shape, the chimneys and its basic façade are very compatible with the other houses in the Rockville Historic District." (Photograph by Elias B. Bull; courtesy of Charleston County Public Library.)

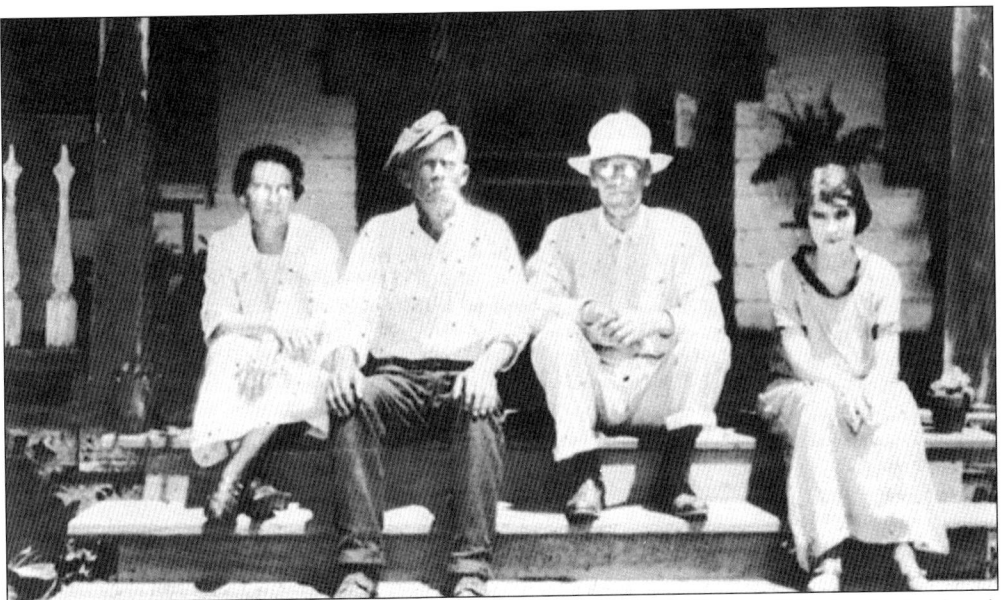

THE WHALEYS AND A FRIEND. This picture from left to right shows Florence Whaley; her husband, Henry Whaley; a friend, Richard Paine; and their daughter, Gladys Whaley, sitting on the steps of their house. (Photograph courtesy of Annabeth Proctor from Ben and Sally Whaley.)

HENRY'S CHILDREN. Gladys Leola Whaley (left) was born on June 22, 1899, on Wadmalaw Island. She married Herbert M. Smith, had no children, and died on December 23, 1957. Gladys's brother, Ephraim "Buster" Clark Whaley, was born on June 25, 1902, in Rockville, married Cornelia Jenkins Whaley (right), had four children, and died on August 9, 1970. They are both buried at St. John's Episcopal Church on John's Island. His four children were Ephraim Clark Whaley Jr., William Henry Whaley, Cornelia Ann Whaley, and Benjamin Seabrook Whaley. (Photographs courtesy of Annabeth Proctor from Ben and Sally Whaley.)

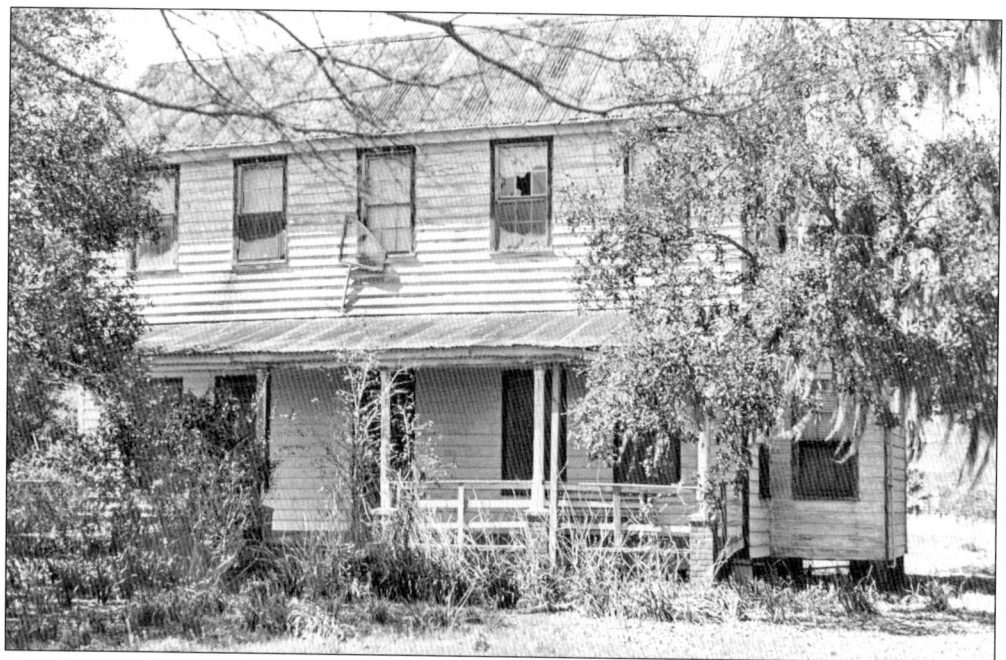

THE JOSEPH JENKINS WILSON HOUSE. Historian Elias Bull wrote that this typical Rockville house was built close to the ground with an offset chimney. It is rectangular in shape and has a one room extension and a one-story porch with a short flight of brick steps to a low-shed roof. (Photograph by Elias B. Bull; courtesy of Charleston County Public Library.)

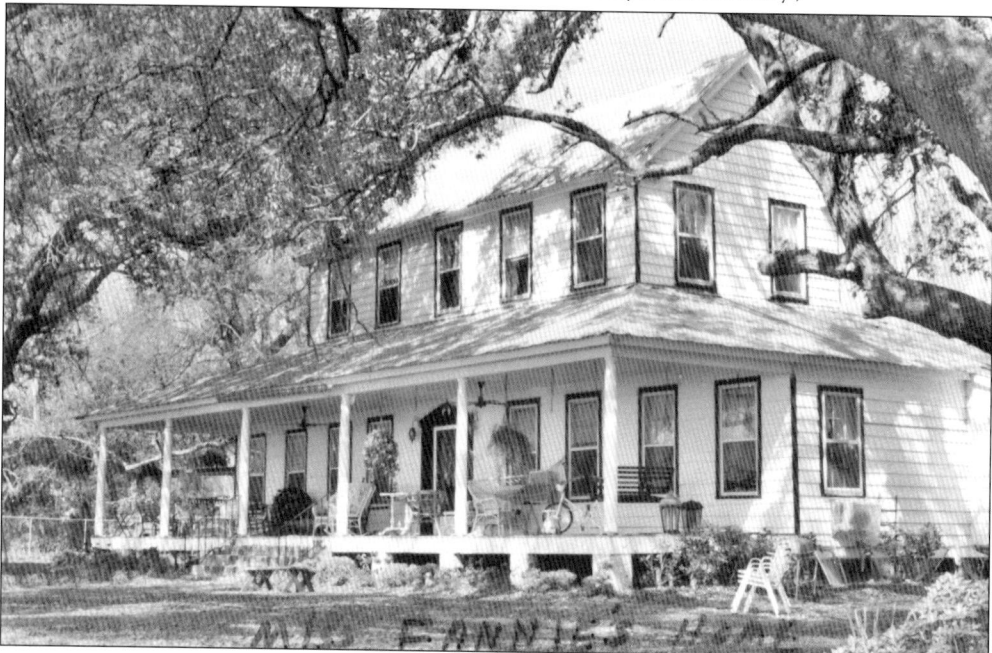

THE JOSEPH JENKINS WILSON HOUSE. This house was originally built for Oliver and Sarah Ann Taylor shortly after they acquired the property in 1898. It is also known as the Fannie Sams Wilson House. Fannie's grandson, Capt. Sandiford Bee, and his wife, Rosamund Ravenel Bee, renovated and moved into this house. (Photograph courtesy of Sandy and Rosie Bee.)

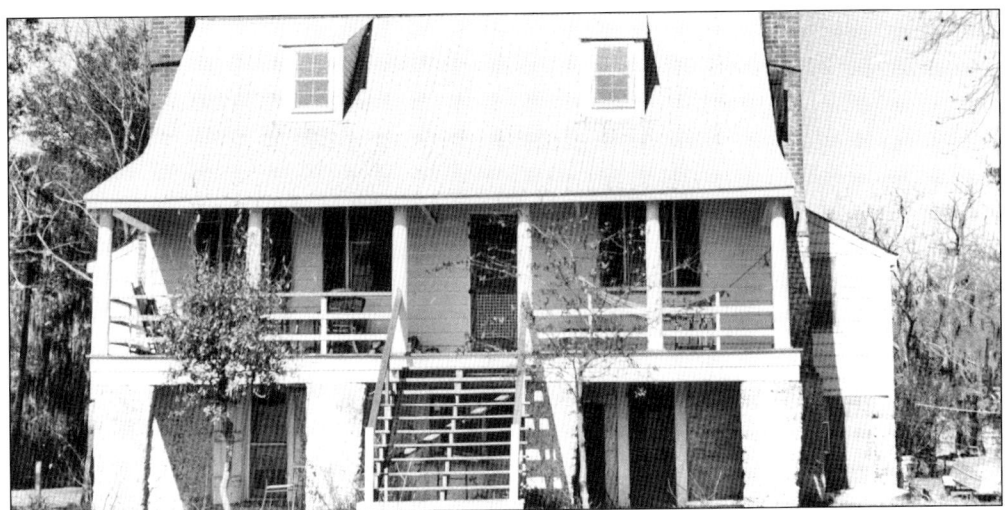

THE MICAH JENKINS HOUSE. Benjamin Jenkins bought the 496-acre "Rocks" plantation, which included an 18-acre island, from Thomas and Mary Tucker for £7,936. The house on this property, the oldest in the village, was probably built before 1776 because Mr. Tucker includes his houses, outhouses, buildings, gardens, orchards, woods, and timber trees in his sale to Jenkins on December 20, 1776. Benjamin's nephew, Micah Jenkins, born on January 8, 1754, and planter of John's Island, possibly bought this particular lot and house from his uncle. The clapboard-sided cottage has been well preserved, is a story and a half, and has basement rooms formed with tabby. These were used as schoolrooms for the children of the village in the early years. William Seabrook of Edisto used this house for his Edisto Island Ferry Company, and by 1824, the road now called Maybank Highway was called the "High Road to Rock Landing," which ended at Seabrook's Rockville ferry house. (Photograph by Elias B. Bull; courtesy of Charleston County Public Library.)

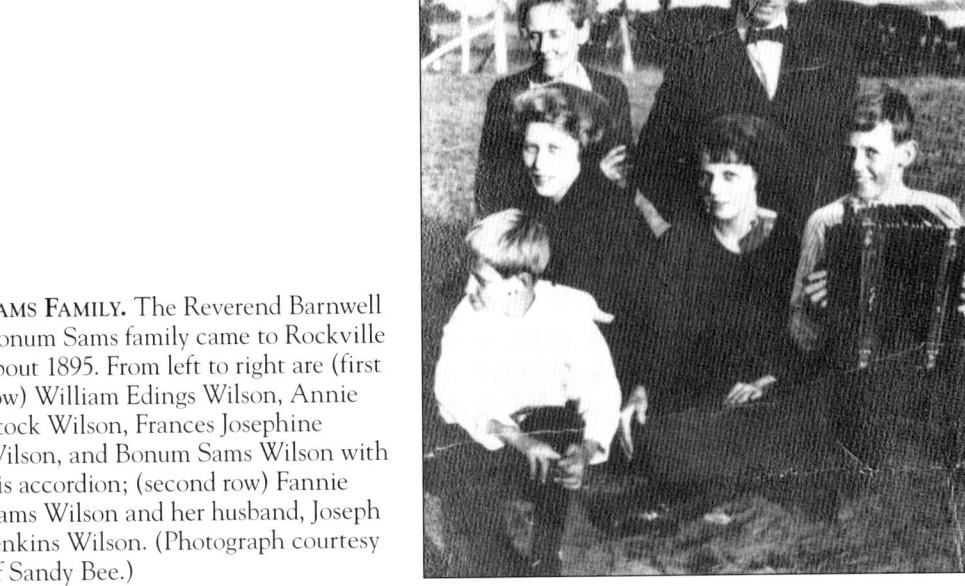

SAMS FAMILY. The Reverend Barnwell Bonum Sams family came to Rockville about 1895. From left to right are (first row) William Edings Wilson, Annie Stock Wilson, Frances Josephine Wilson, and Bonum Sams Wilson with his accordion; (second row) Fannie Sams Wilson and her husband, Joseph Jenkins Wilson. (Photograph courtesy of Sandy Bee.)

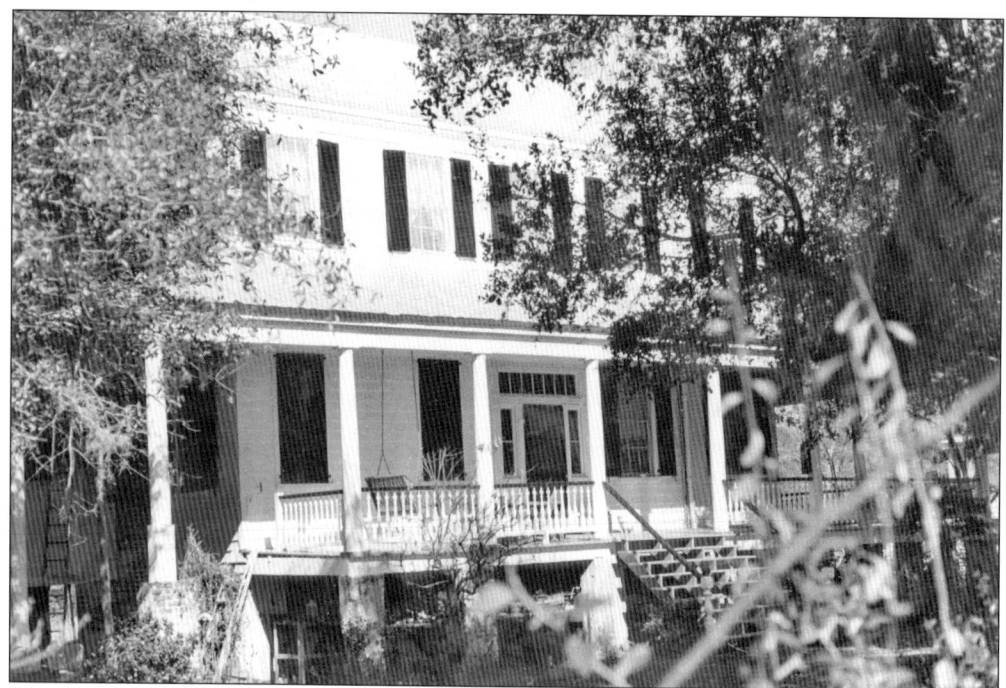

THE MAJOR DANIEL PERRY JENKINS HOUSE. The first-known occupants of this home were Gabriel and Ann Jenkins LaRoche Seabrook, and it was probably built around 1834. The next owner was Maj. Daniel Perry Jenkins, son of Benjamin Jenkins and Elizabeth Perry. Major Jenkins gave this house to his son, Joseph Micah "Joe Mike" Jenkins, who married Elizabeth Frances "Fannie" LaRoche Jenkins. They left their house to their daughter, Elise Jenkins. (Photograph by Elias B. Bull; courtesy of Charleston County Public Library.)

ELISE JENKINS FRAMPTON. Elise married Joel Frampton and sold this house to Capt. William Yates Stevens. His son, Constantine Stevens, bought this house from his mother's estate and in turn left it to his son, Dr. Constantine Yates Stevens, known to most as "Stevie." Stevie lives in Sumter, South Carolina, and is a doctor of pathology. He went to the Wadmalaw Island School, Porter Gaud, the College of Charleston, and the Medical University of South Carolina.

THE TWINS. Constantine "Con" Bailey Stevens (left) and William Yates Stevens were born in Rockville on August 25, 1908, to Virginia and William Stevens. Unfortunately William died as a child on the day his sister, Virginia, was born. (Photograph courtesy of Dellie Eaton.)

VIRGINIA WHITRIDGE BAILEY STEVENS. Virginia was born on September 3, 1874, the daughter of Mary LaRoche and Constantine Bailey. She married William Yates Stevens in Grace Chapel on December 29, 1939, and had three sons—Daniel Augustus and twins Constantine, and William Yates Stevens Jr.—and two daughters—Mary LaRoche and Virginia Bailey Stevens. (Photograph courtesy of Dellie Eaton.)

CAPTAIN WILLIAM YATES STEVENS. Captain "Bill" was born on Edisto Island and became interested in navigation when he was only 15 years old. He worked on numerous boats from many South Carolina ports. Here, standing beside his steps, Captain "Bill" holds his grandson, Marvin Allen Zeigler Jr., son of his daughter, Virginia Bailey Stevens Zeigler, and Marvin Allen Zeigler Sr. (Photograph courtesy of Dellie Eaton.)

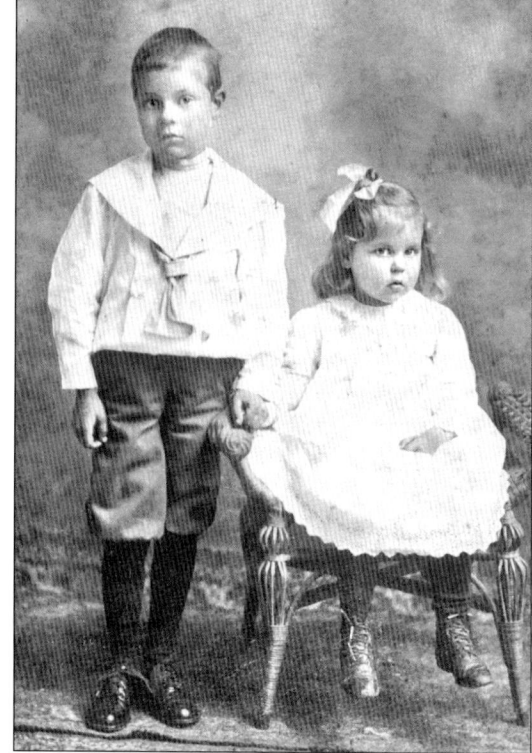

BROTHER AND SISTER. Daniel "Gussie" Augustus and Mary LaRoche Stevens were the two oldest children of Virginia and William Stevens. Gussie was born January 14, 1901. (Photograph courtesy of Dellie Eaton.)

VIRGINIA WHITRIDGE STEVENS ZEIGLER. Virginia was born on February 3, 1912, the youngest child of William and Virginia Stevens. She graduated from the College of Charleston and the University of North Carolina, married Marvin Allen Zeigler from Virginia at Grace Chapel on December 28, 1938, and had two children, Virginia Linette Zeigler Ramsay and Allen Zeigler. She died on September 30, 1990. (Photograph courtesy of Dellie Eaton.)

MARY LAROCHE STEVENS. Mary was the eldest daughter of William and Virginia Stevens. She was born on November 6, 1905, graduated from the College of Charleston in 1920, and died on February 13, 1946. (Photograph courtesy of Dellie Eaton.)

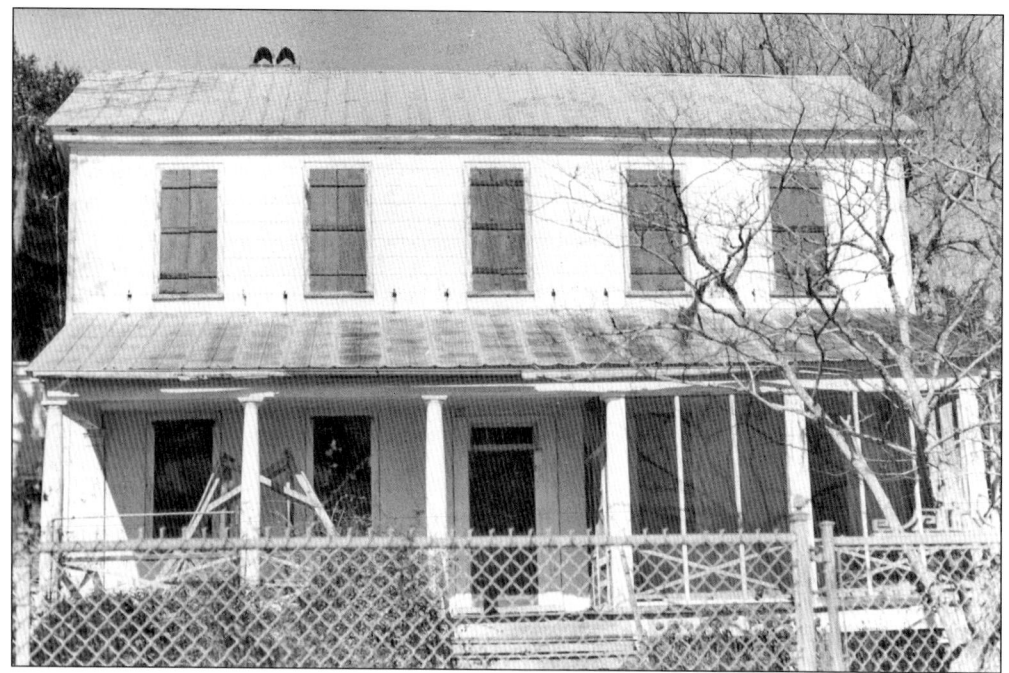

OSMA BAILEY. Osma Bailey and his wife, Electra Virginia Whitridge Bailey, may have been the first inhabitants of this house. Osma was born on December 20, 1825, married Virginia on May 12, 1847, had 10 children, and died on January 11, 1898. His father-in-law, Dr. Joshua Barker Whitridge, owned Rosebank Plantation. (Photograph by Elias B. Bull; courtesy of Charleston County Public Library.)

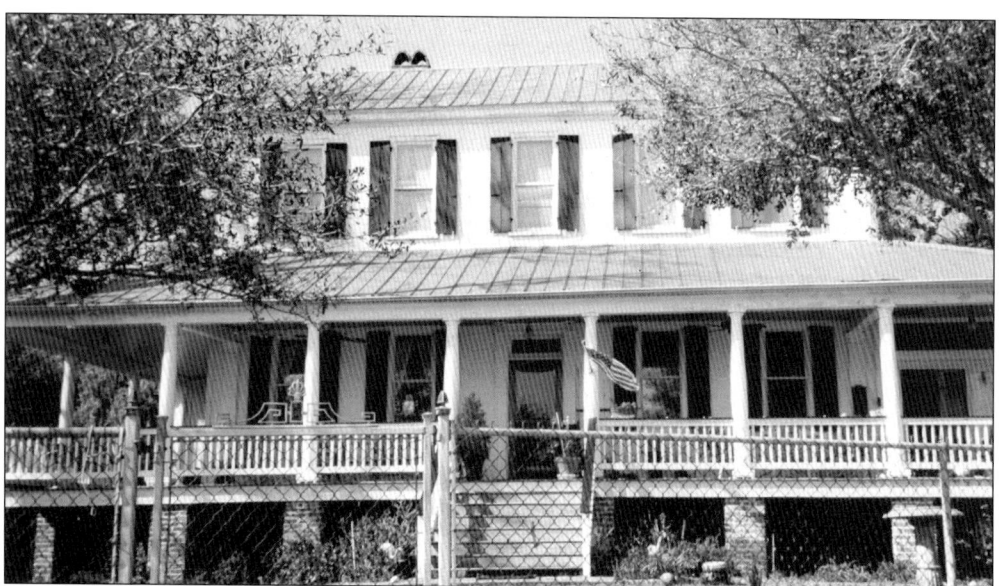

THE OSMA BAILEY HOUSE. Historian Elias Bull reported that this house was probably built before 1838. It sits six feet off the ground on tabby pillars, has a one-story porch, and six-foot-wide wooden steps. This house fits very well on its lot.

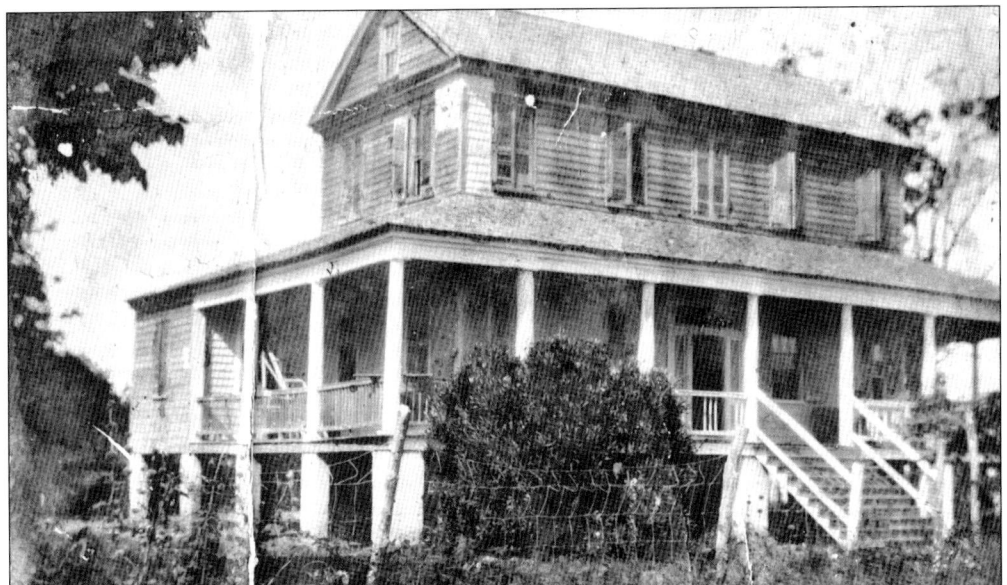

THE JAMES LAROCHE HOUSE. Elias Bull states that this house was probably built by Edward D. Bailey about 1838 for Dr. Edward M. Beckett. The front and rear entrances have wide wooden stairs. The 19th century summer house is high off the ground where the breezes can circulate more easily. "The wide, three-sided veranda provides ample shade, while the low hipped roof prevents the accumulation of hot air." (Photograph courtesy of Jean Townsend.)

WILLIAM EVANS JENKINS FAMILY. This photograph was taken about 1901 of the family who lived in the James LaRoche House for many years. From left to right are William "Willie" Evans Jenkins; his daughter Annie Jenkins; his son Julian Jenkins; his sister, Miss Rose Jenkins; his other son, William "Bill" Hamilton Jenkins; and his wife, Julia Septima Jenkins. "Willie" was born on March 5, 1851, married Julia in 1893, had four children, and died on April 9, 1930. His daughter, Mary Amarinthea, had not yet been born. (Photograph courtesy of Jean Townsend.)

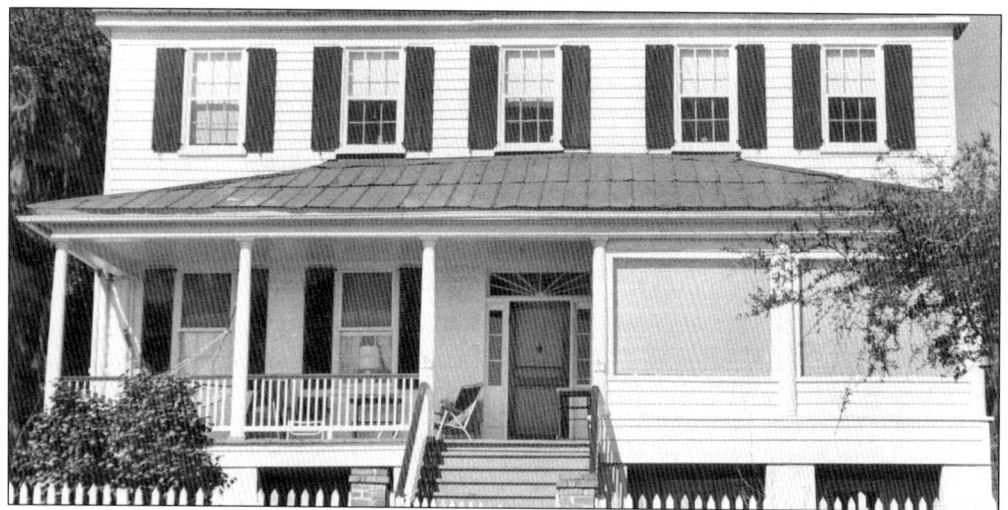

THE JOHN CALDER WILSON HOUSE. John Wilson built this house on land that had once been owned by William Seabrook of Edisto. In February 1829, Seabrook conveyed his ownership of the property to this renowned local surveyor, and Wilson quickly hired Benjamin F. Scott to build him a summerhouse with perfectly matching bay windows, rooflines, and supporting columns. Wilson was also a planter and was married to Susanna Smith Wilson. This well-constructed house became the Episcopal rectory in 1836, and it continued to house clergymen and their families until 1946, when longtime bishop Albert S. Thomas's wife, Emily Jordan Carrison Thomas, bought the house and now half-acre lot. (Photograph by Elias B. Bull; courtesy of Charleston County Public Library.)

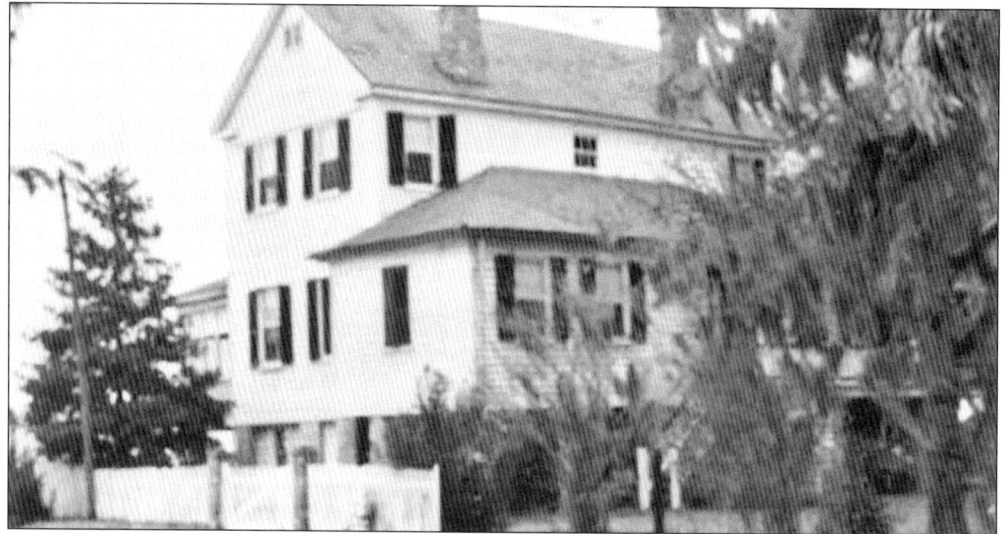

THE EPISCOPAL RECTORY. In 1834, a plan was initiated to have the minister of St. John's Episcopal Church on John's Island stay year-round in the village of Rockville to hopefully insure his and his family's health against the dreaded summer fever. It was determined that a summerhouse be secured, and at a vestry meeting on March 6, 1836, it was agreed upon to purchase the house and lot of the late John Wilson for the sum of $1,000. The Reverend Thomas John Young and his family were the first to live in this village rectory. Unfortunately a fatal disease quickly killed several members of his family. And since neither village church had a graveyard, they were buried in the graveyard at St. John's. (Photograph courtesy of Dellie Eaton.)

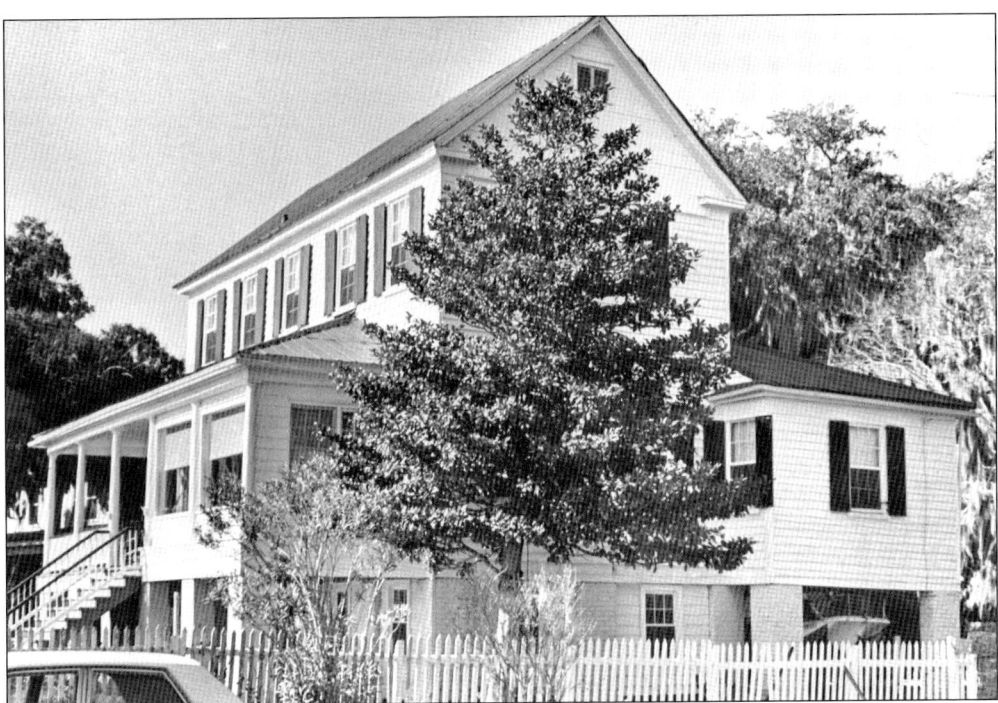

THE EPISCOPAL RECTORY. Elias Bull considered this residence to be "the most perfectly symmetrical house in all of the village of Rockville: the perfect matching of the bays above and below the roof lines; the front and rear hipped roofs, the nearly perfect placing of the columns supporting the roof; and the location of the front porch stairs. The rear façade matches that of the front, the only difference being that it is entirely enclosed as opposed to the open front porch." (Photograph by Elias B. Bull; courtesy of Charleston County Public Library.)

A VIEW FROM THE WATER. This photograph shows Edwin "Bates" Wilson's windmill, dock, and house (left) before the third story was added, and the Episcopal rectory (right). Before Bates built his house in 1920, this area had been used for recreation and was known to everyone as "The Green." (Photograph courtesy of Emily Leland.)

THE EDWIN BATES WILSON HOUSE. Bates Wilson built this two-story house in 1920 on "The Green." (Photograph courtesy of Emily Leland.)

THE "WEDDING CAKE" HOUSE. After Bates Wilson added a third floor to his house, it was often referred to as the Wedding Cake House. The three-tiered effect looks especially pretty in this photograph taken after a rare snowfall. (Photograph courtesy of Dellie Eaton.)

THE AGNES WILKINSON WILSON WINDMILL. Elias Bull reports that "this windmill, bought and installed about 1922 to supply water to a nearby residence, is one (of two) in Rockville. With the increasing impact of technology which allows every isolated home to receive the amenities of contemporary life and the ever accelerating tempo of day to day living, it is refreshing to find evidence of a slower and more relaxed day and age." (Photograph by Elias B. Bull; courtesy of Charleston County Public Library.)

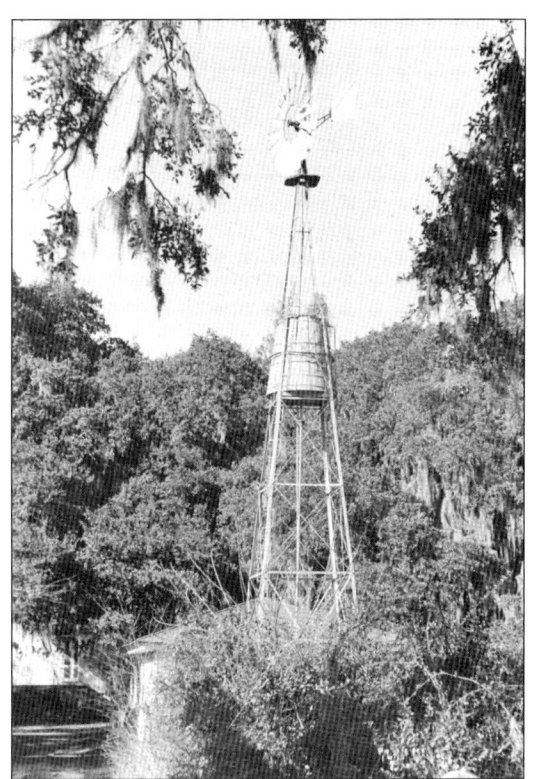

AGNES WILKINSON WILSON. Agnes was born on April 29, 1883, the daughter of Edward Girardeau and Mary Ida Warren Wilkinson; she married Edwin Bates Wilson; had one daughter, Martha Mary "Mattie" Wilson on July 1, 1906, and died on March 25, 1955. Her sister was Tahloulah W. Wilkinson LaRoche. (Photograph courtesy of Dellie Eaton.)

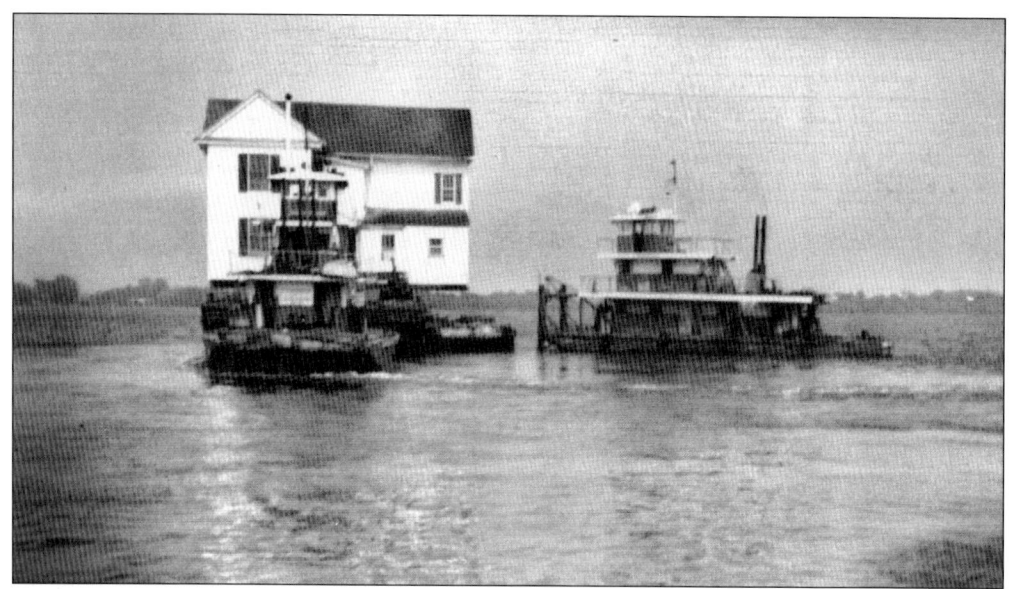

Two Tugs. The *Cornwallis* (left) and the *Pocahontas* (right), two Stevens Line boats, are towing the barge bringing Ladson Webb's house from John's Island to Rockville. (Photograph courtesy of Dellie Eaton.)

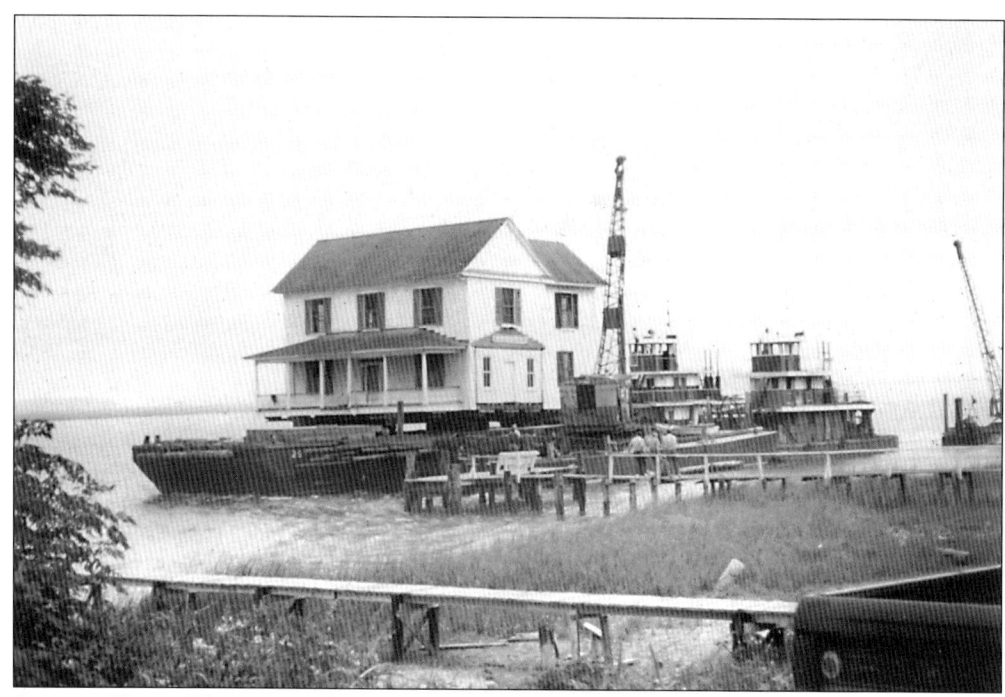

Almost Home. This picture shows Webb's house in Bohicket Creek off Rockville's bluff edge. The Chitwood Company moved the house on John's Island onto the barge, and the Stevens Line moved it by water to Rockville.

26

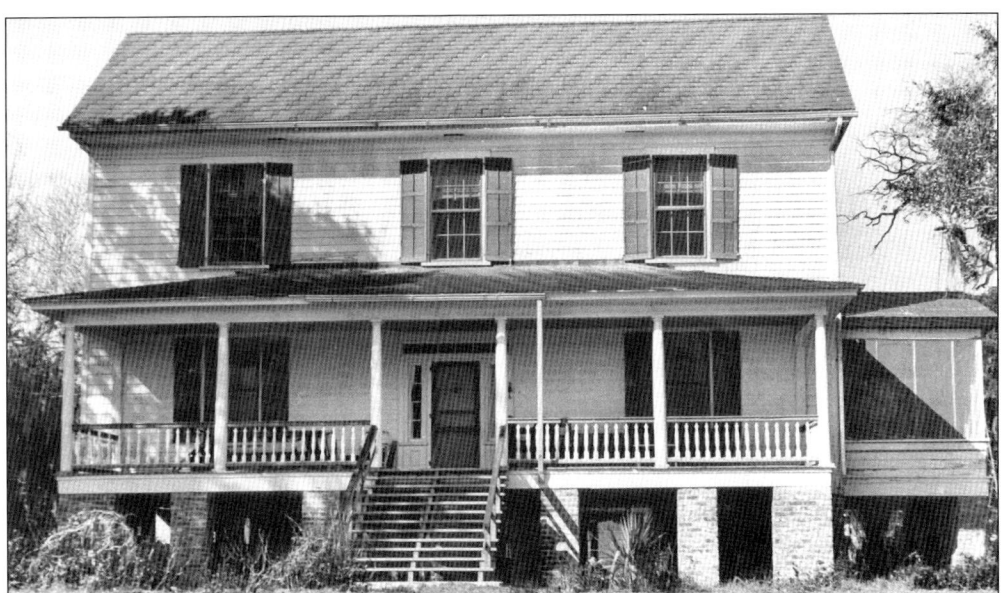

THE T. LADSON WEBB HOUSE. Elias Bull says that "tradition states that this present house was originally a third of a plantation house near Orangeburg, South Carolina. When the owner of this house died, the house was divided into three parts. One of these parts was moved to Exchange Plantation on John's Island, probably after the Civil War. Around the middle of May 1970, it was moved again to a waterfront lot in Rockville to replace a house, which had burned in 1969. It is unknown what the original plantation house near Orangeburg looked like, but the appearance of the house as it stands today is the same as it was on John's Island." (Photograph and Elias B. Bull; courtesy of Charleston County Public Library.)

THE T. LADSON WEBB HOUSE. This is the view of the Webb house from the rear. (Photograph by Elias B. Bull; courtesy of Charleston County Public Library.)

THE BENJAMIN BAILEY HOUSE. This late-19th-century photograph shows the following houses from left to right: the Benjamin Bailey House, the John Wilson House, the Major Daniel Perry Jenkins House, the Osma Bailey House, and the Micah Jenkins House. The large oak tree in this photograph was the starting point for many a sailboat race, and the benches built around its base were perfect for conversations and views of sunrises and sunsets. (Photograph courtesy of Jean Townsend.)

THE GREEN. The villagers often met at the Green, an open area in the center of the village, where they all gathered to visit. Blanche Townsend McChesney remembers that there were "many large oak trees with soft gray moss hanging from their branches. Here the village families—from grandparents to infants—gathered to visit or participate in games such as baseball, croquet, tennis, and at one time jousting tournaments." Bates Wilson built a house on the site years later. (Photograph taken by Edward "Ned" LaRoche Jenkins; courtesy of Jean Townsend.)

THOMAS CONSTANTINE BAILEY JR.
Thomas was born on January 14, 1888, married Alice Glen Whaley, had three children, and died on September 4, 1950. His parents were Thomas Constantine and Susan Mary LaRoche Bailey. (Photograph courtesy of Dellie Eaton.)

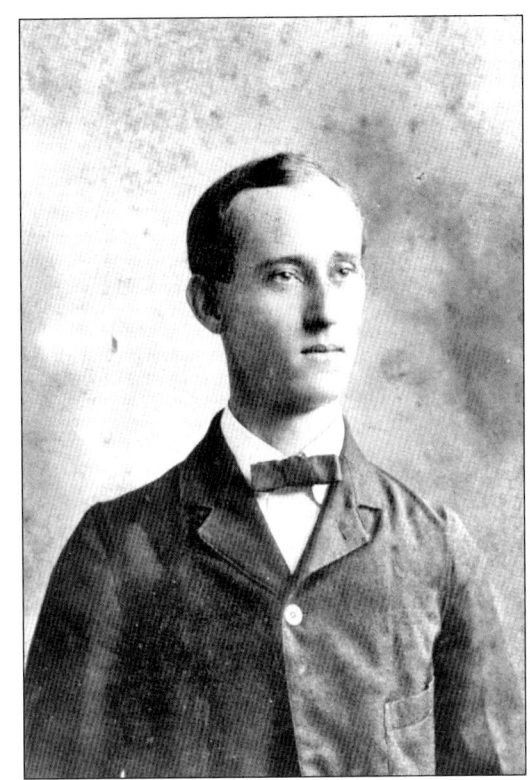

EVELINA LaROCHE BAILEY KING. Evelina was born on June 25, 1883, married Preston Moore King in Grace Chapel on October 25, 1908, had seven kids, and died on October 6, 1933. Thomas and Evelina were brother and sister. Evelina was Judy King Shuggs's grandmother. (Photograph courtesy of Dellie Eaton.)

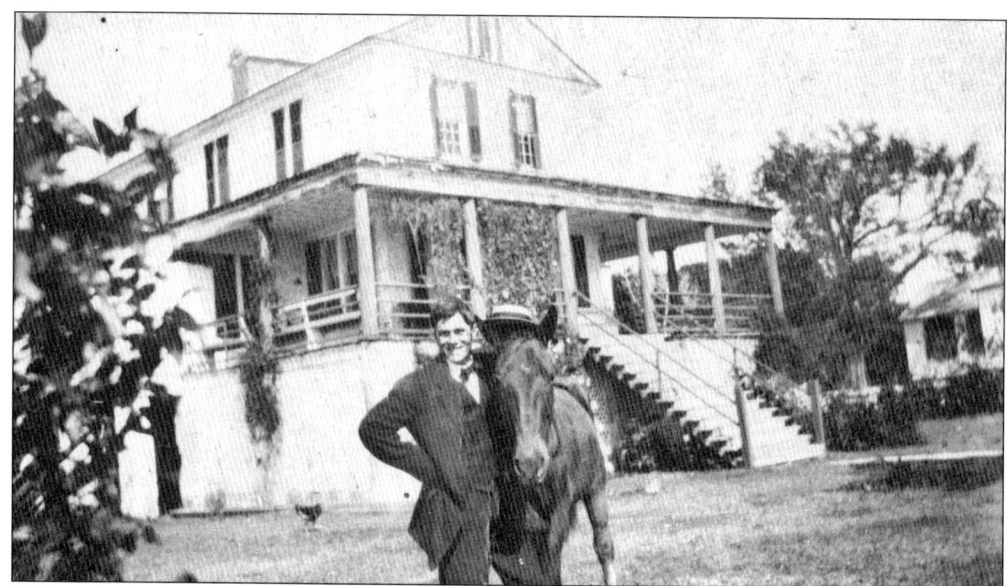

DR. DANIEL JENKINS TOWNSEND HOUSE. Kate McChesney Bolls tells that her great-grandfather built his summer home in the late 1830s. This lot was part of Dr. Townsend's Rockland Plantation. Bolls says that "there was a very large front yard with orange, apricot and great oak trees. The front fence was moved back several times as storms wore away the bluff along the river." This photograph, taken about 1913, shows Dr. Townsend's grandson, Henry Evans Townsend, in the front yard. (Photograph courtesy of Jean Townsend.)

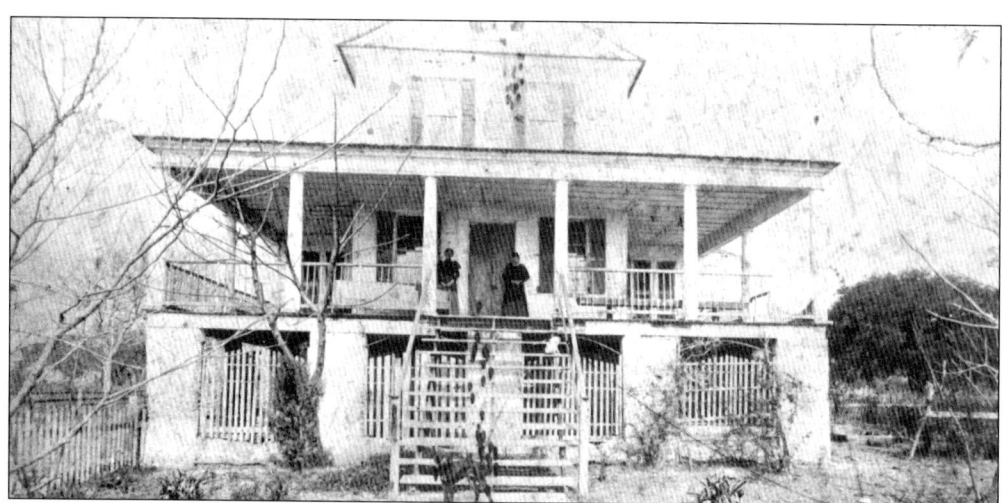

THE DANIEL J. TOWNSEND HOUSE. In this photograph, taken about 1895 by Edward LaRoche "Ned" Jenkins, Miss Rose Jenkins and Mrs. James Swinton Townsend (Mary Amarinthea Jenkins) are on the porch. Mary Buskovitch remembers that Claude Townsend and Mary Amarinthea's sister, "Lizzie" Jenkins, "were the last two family members to live in the original house. After they left the village, the house remained vacant for about twenty-five years. The coastal storms, the winds and rains gradually did considerable damage. The tin on the roof began to come off, and the porches fell down." (Photograph courtesy of Jean Townsend.)

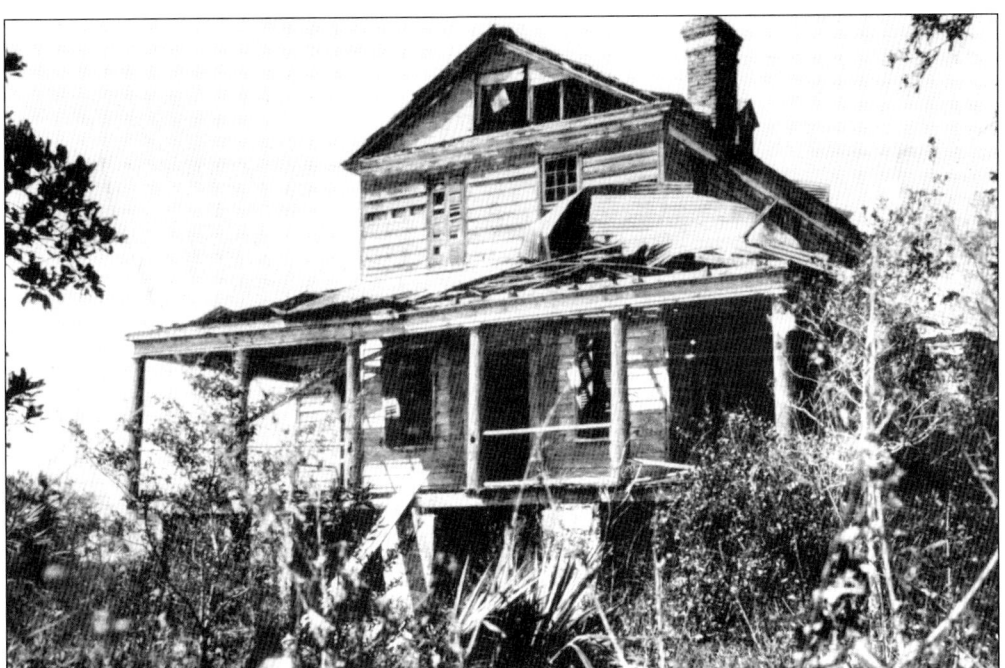

THE DANIEL J. TOWNSEND HOUSE. Mary Amarinthea remembered that "the summer house in Rockville where I lived was a big airy one and with two fireplaces upstairs and down. It was right on the Bohicket River with a wide street in front of the house where the buggies or wagons could be driven. Alas, the river has taken a lot of this river front. There were oaks trees all along the front there and all through the village." (Photograph courtesy of Jean Townsend.)

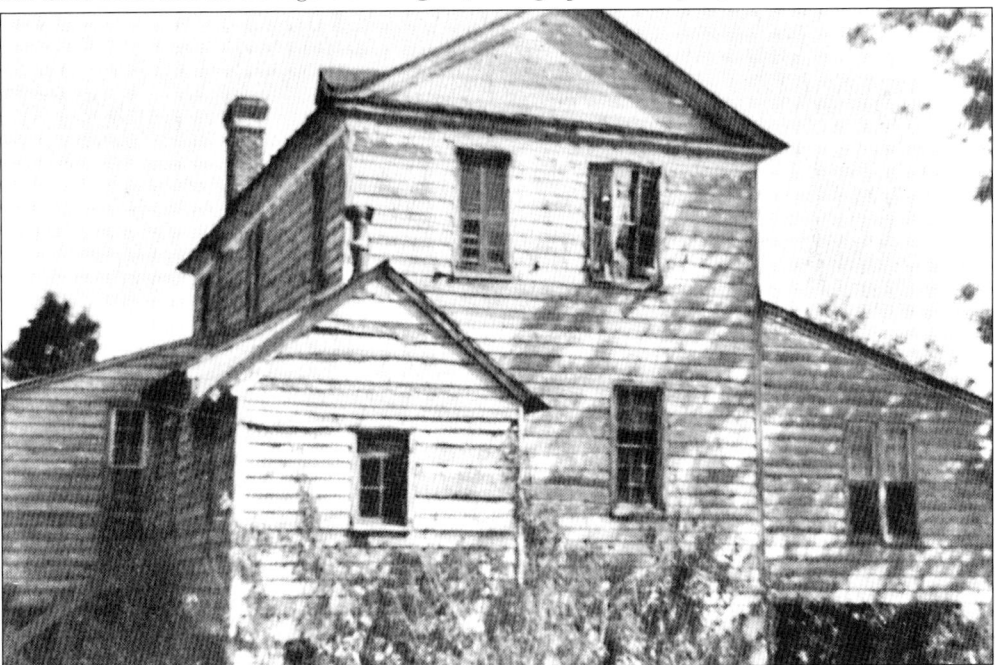

A REAR VIEW. This photograph was taken of the back of the house in the early 1940s. (Photograph courtesy of Jean Townsend.)

THE STREET ALONG THE BLUFF EDGE. This photograph was taken about 1880 by Edward "Ned" LaRoche Jenkins, who had a photography business in New Jersey. Mary Townsend tells the story about how she, Harry Barnwell, Dan ?, Foggy Bailey, and Celia ? would meet Bing Jenkins, the island mail carrier, at the head of the road that led into Rockville. They would ride on the truck's running boards as he delivered the mail on the dirt road located between Bohicket Creek and the village houses. (Photograph courtesy of Jean Townsend.)

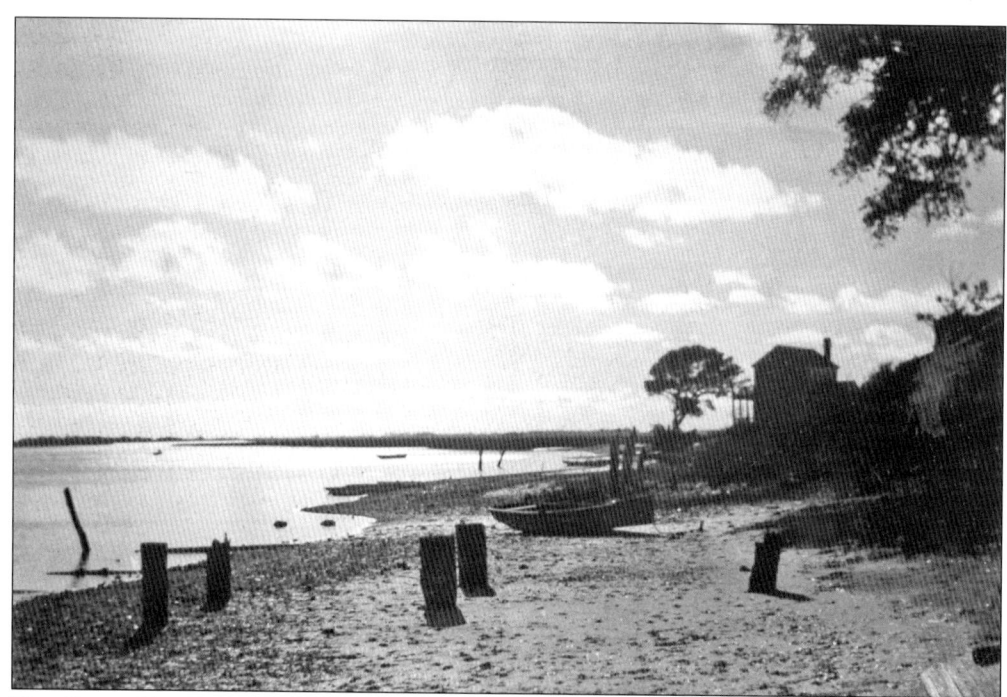

THE BLUFF EDGE. Sophie Jenkins tells about "the Hurricane of 1893, which came on August 27, 1893, and brought a tidal wave that took 50 feet off the bluff along Rockville's waterfront including every wharf. As a result, Rockville lost some of its waterfront; for older residents remember when great oaks stood between the houses and the river, and carriages could be driven the entire length of the village." This photograph shows the damage of the storm between the Joseph Edings LaRoche House and the John Ferrars Townsend House. (Photograph courtesy of Jean Townsend.)

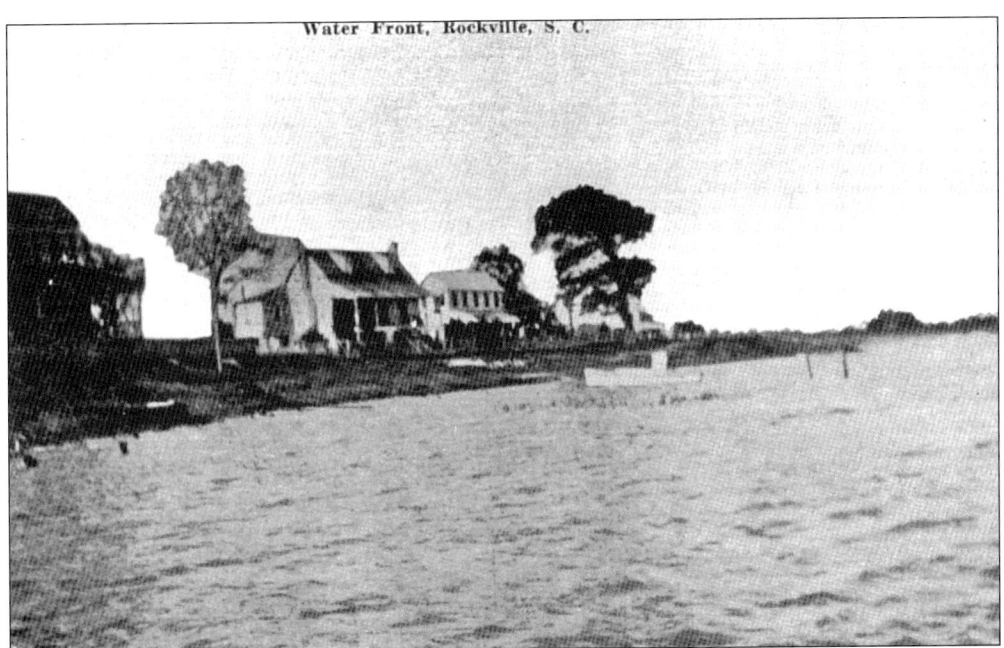

A 1919 POSTCARD. This postcard says "Waterfront Rockville, S. C." and was sent to Mrs. James Clark Seabrook on August 12, 1912, from Edward LaRoche "Ned" Jenkins and reads, "Dear Mamie, I did not get the photos of Rockville I wanted. ELJ" (Postcard courtesy of Kathie Jordan and Shannan and Edward Anderson.)

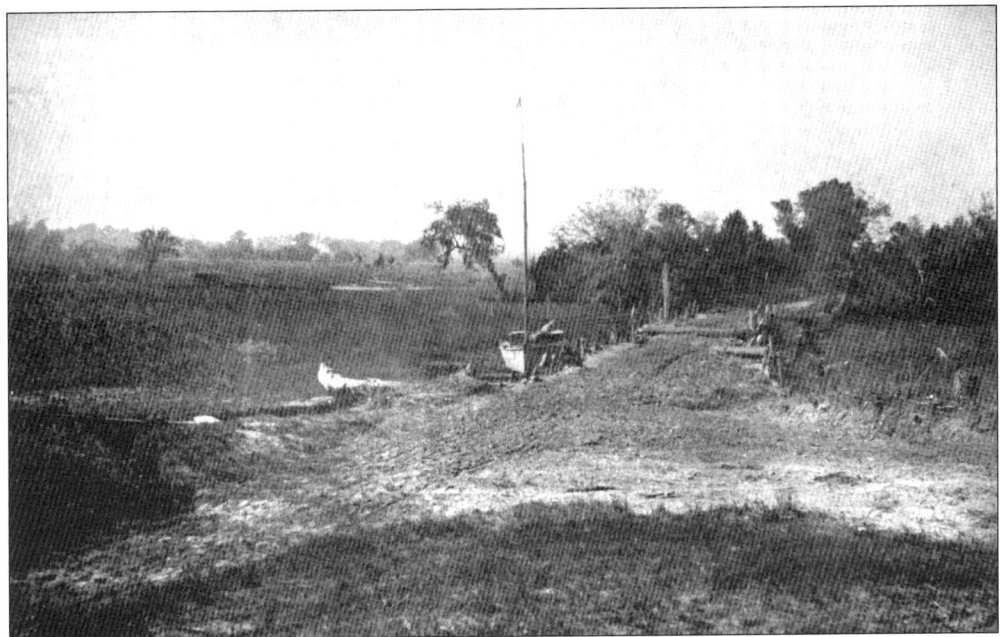

LINTON CAUSEWAY. The owner of this property, Dr. Irvin Grier Linton, created this man-made causeway across Breakfast Creek on the western side of Rockville about 1969. Mr. Epps constructed the causeway with Donald and Steve Proctor's help. Dr. Linton was born in 1907 and died in 1997. His son, Irvin Grier "Chip" Linton, married Margaret Rose McChesney, granddaughter of the Reverend Paul Stanley McChesney. (Photograph courtesy of Jean Townsend.)

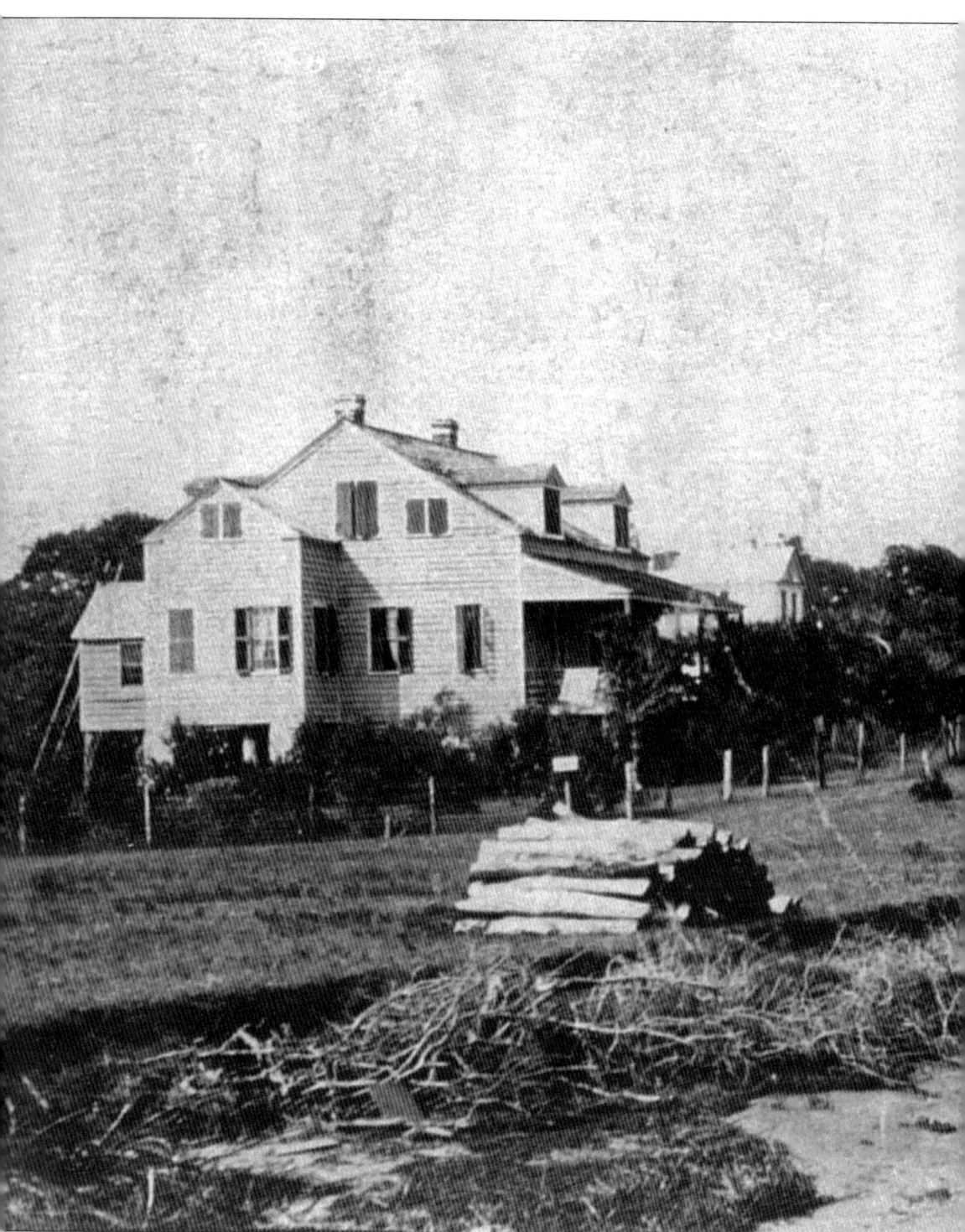

ROCKVILLE'S BEACH. After the Hurricane of 1893, much of Rockville's bluff edge was swept into the creek. In the 1930s and 1940s, villagers could walk right out of their front doors and right onto their own beach. Blanche McChesney remembers "We would go swimming and rowing

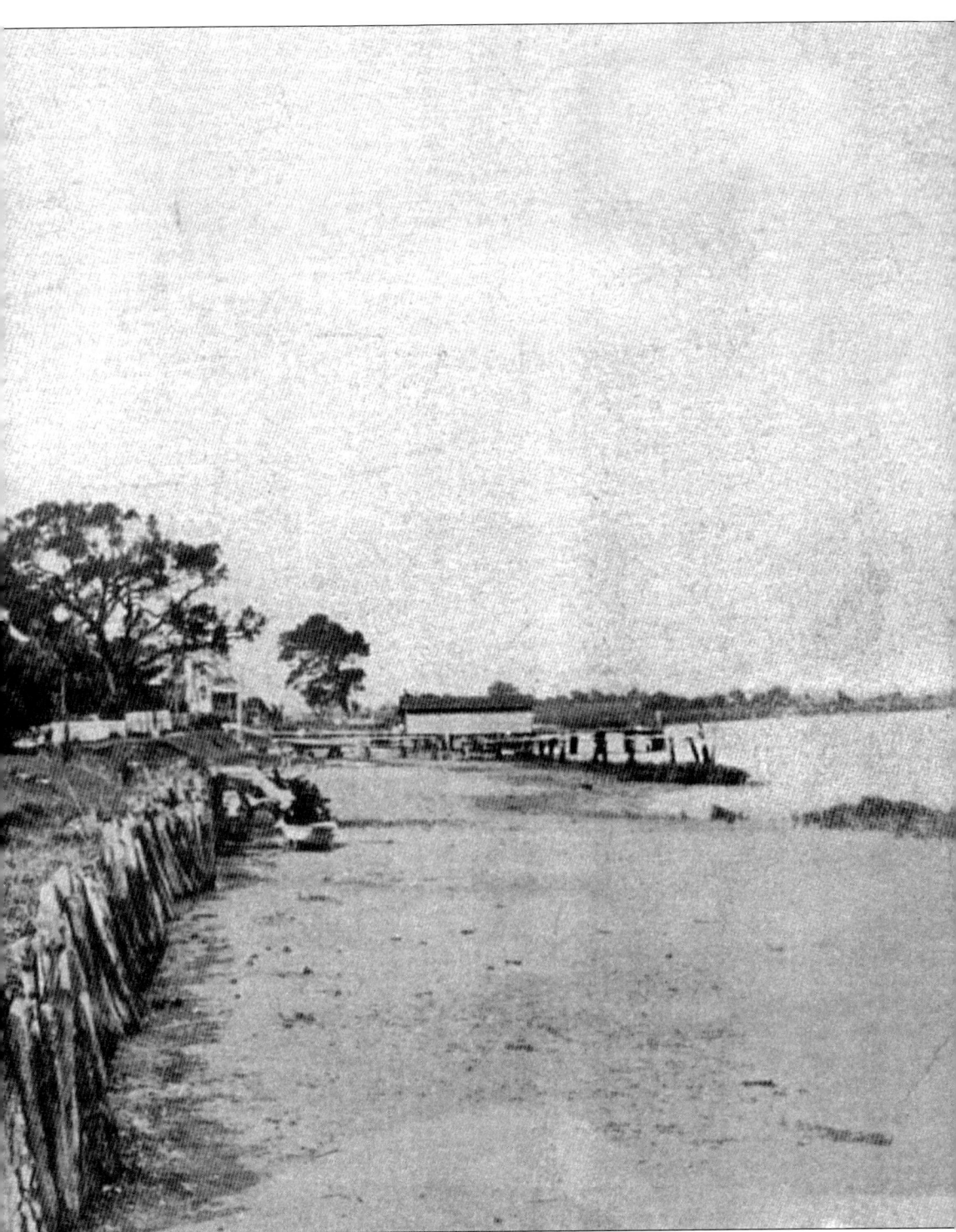

and sailing on the river. There was always a sound of some kind—the waves washing against the shore or the lap, lap of the water against the boats and wharves." (Photograph courtesy of Kathie Jordan and Shannan and Edward Anderson.)

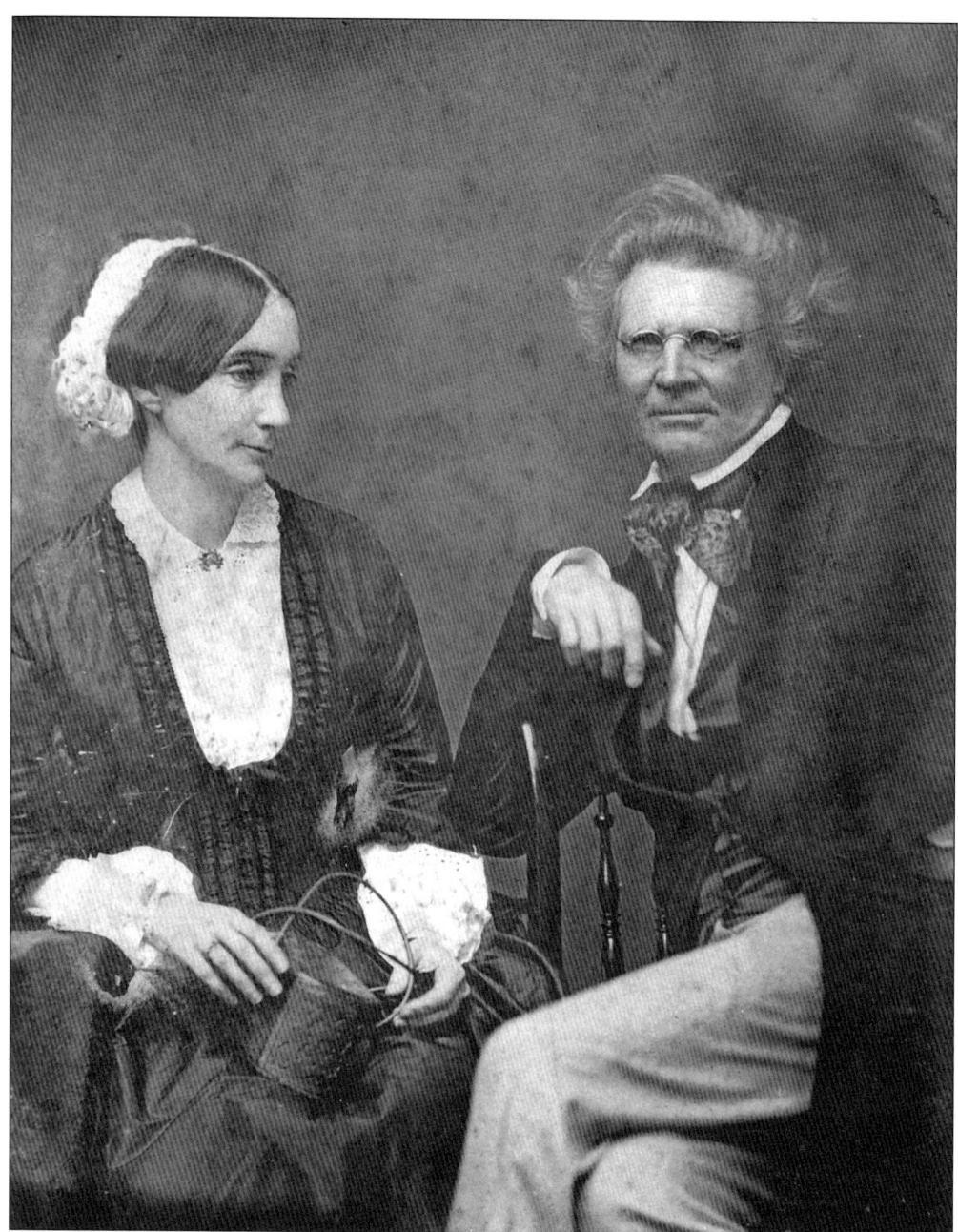

JOHN FERRARS TOWNSEND. On October 23, 1799, John Townsend was born to Daniel and Hephzibah Townsend of Bleak Hall Plantation on Edisto Island. He married Mary Caroline Jenkins, daughter of Capt. Richard and Phoebe Waight Jenkins of Bugby Plantation, on January 22, 1835. They had four children—Phoebe Waight Townsend, Mary Caroline Townsend, Susan Grace Townsend, and John Ferrars Townsend Jr. John was a South Carolina state senator from 1850 to 1858, and he also signed the Ordinance of Secession. He died on February 3, 1881. John's father, Daniel Townsend, built a story-and-a-half house shortly after his marriage to Mary Caroline Jenkins of Wadmalaw, between 1834 and 1840. In later years, it had the distinction of being the birthplace of Congressman George Seabrook Legare.

THE JOHN FERRARS TOWNSEND HOUSE. Historian Elias Bull states that this "square, wooden house that stands on the original site where tradition states it was built by John F. Townsend in the early part of the 1800's." The house must have been built between 1834 and 1840, shortly after his marriage to Mary Caroline Jenkins of Wadmalaw. Because his mail was constantly getting mixed up with the other John Townsends on the island, he added a middle initial of "F," which later came to stand for the name Ferrars, a favorite English general bearing the same name.

TWO COUSINS. John Ferrars Townsend III, M.D. (left) was the two-year-old grandson of John Ferrars Townsend who was born on Edisto Island on April 22, 1880. His parents were John Ferrars Townsend Jr. and Ellen M. Legare. John Ferrars Sosnowski (right) was also born on Edisto Island on March 22, 1869. His parents were Dr. Julius Christian and Susan Grace Townsend Sosnowski.

DR. JULIUS CHRISTIAN SOSNOWSKI. Dr. Julius was born on December 5, 1840, in Lithuania, the son of Madame Sophia Wentz and Joseph Stanislaus Sosnowski. He married Susan Grace Townsend on February 14, 1867. They had five children—John Ferrars, Joseph Stanislaus, Mary Caroline, Sophia Wentz, and Julius Christian Sosnowski. Julius died of diphtheria at age 36 in August 21, 1876, before the birth of his youngest son. He served as a physician for the Confederacy during the War Between the States.

SUSAN GRACE TOWNSEND SOSNOWSKI. Grace was born in January 13, 1844, as the daughter of John Ferrars Townsend and Mary Caroline Jenkins Townsend, and she died on October 3, 1920. She attended Madame Sosnowski's Girls School in Barhamville, South Carolina, near Columbia. Madam's son, Julius Christian, had studied to be a doctor. They later married, and Grace's father wanted them to live with him at Bleak Hall. After Grace's husband and parents died, she moved to Rockville with her unmarried daughter, Sophie.

THREE LOVELY LADIES. From left to right, Mrs. James Clark Seabrook (Martha Evelina LaRoche); her daughter-in-law, Mary Caroline Sosnowski Seabrook; and Mary's sister, Sophie Sosnowski, are standing in their yard in Rockville. Mrs. James Clark Seabrook was born on October 27, 1836, married Dr. James Clark Seabrook on April 19, 1855, had four children, and died on April 13, 1909. Their family had evacuated to Cheraw during the War Between the States. (Photograph courtesy of William Jenkins Seabrook.)

TWO SISTERS. Mary Caroline and Sophie Sosnowski were the only daughters of Dr. Julius Christian Sosnowski and Susan Grace Townsend Sosnowski. They lived on Bugby Plantation during the winter months.

THE JOHN F. TOWNSEND HOUSE. This house was left to Sophie Sosnowski. When her mother became ill, she went three miles up the road to Allandale Plantation to care for her. During this time, Sophie rented her house out to nice families. Before she died, in her will, Sophie left the house to her niece, Sophia Seabrook Jenkins, for her lifetime and to her grandnephew, the Reverend Frederick S. Sosnowski, after that time.

SOPHIE SOSNOWSKI. Sophie was born on April 21, 1874, the daughter of Susan Grace and Dr. Julius Christian Sosnowski. She never married and died on August 31, 1954. She loved to go over to the Green in the summertime and play the violin in the Hall. Blanche McChesney tells that "Mr. Fripp could play the violin, as could Julius Townsend, and there was a (Negro) man with an accordion who could be hired for fifty cents a night. While the young folks danced, the older ladies and gentlemen danced or sat on the bench and discussed the events of the week."

JAMES CLARK SEABROOK JR. "Jimmie" was born on September 30, 1862, married Mary Caroline Sosnowski Seabrook on February 9, 1893, had four children, and died October 3, 1940. His parents were Dr. and Mrs. James Clark Seabrook who owned a house in Rockville and a plantation about three miles north of the village called Seabrook Plantation, but it is now known as Allandale Plantation.

MARY CAROLINE SOSNOWSKI SEABROOK. Mary Caroline was born on February 3, 1873, at Bleak Hall Plantation on Edisto Island. She married James Clark Seabrook Jr; had children Sophia Augusta, Grace Sosnowski, Oliver Francis, and Claudia Wilkinson Seabrook; and died on July 31, 1961. Jimmie moved her and her widowed mother, Susan Grace, from Bleak Hall to Rockville in 1890.

THE JOHN F. TOWNSEND HOUSE. Elias Bull reports that this house was built "as a simple summer residence for the plantation owners of Wadmalaw, Edisto, and Johns Island is typical of most of the other homes here with its tabby foundations and cellar, its story-and-a-half height and chimneys on the rear sloping roof. The rear addition of a later date continues the same pleasing appearance. The 'board-fence' to enclose the front porch adds to its charm as a rural summer village house, which it is." (Photograph by Elias B. Bull; courtesy of Charleston County Public Library.)

MOTHER AND DAUGHTER. This photograph shows Mary Caroline holding her daughter, Sophie Seabrook. Sophie was probably about one year old in this picture.

WILLIAM HAMILTON JENKINS. Bill was born on December 17, 1893, and went to the public school on the island in Rockville. He attended Porter Military Academy one year, and in the fall of 1911, he entered Presbyterian College with the idea of becoming a minister. His plans changed, and he entered Clemson College, graduating in 1916. Sometime in the summer or fall of 1917, Bill volunteered for the Navy. From about the early 1920s until his retirement in 1957, Bill was in Haiti and then with the Department of Agriculture. He finally married on April 26, 1930. Unfortunately Bill died on November 22, 1960, only three years after he retired.

SOPHIE JENKINS. Sophie tells about her life: "I was born a Seabrook, the oldest child of James Clark Seabrook, cotton planter of Wadmalaw Island, and his wife, Mary Caroline Sosnowski. My birth took place on Wadmalaw Island, August 31, 1895, on the plantation, Allandale, where my parents lived with our grandparents, Dr. and Mrs. James Clark Seabrook."

THE JOSEPH EDINGS LAROCHE HOUSE. This house, next to the Sea Island Yacht Club, was built around 1835 for Joseph Edings LaRoche. The house is also referred to as the Ned Seabrook House, for Edmund "Ned" Bellinger Seabrook and his wife, Susan "Susie" Giradeau Jenkins, acquired this summerhouse next. Ned farmed at Jenkins Point on Johns Island and used to row himself across Bohicket Creek to work each day. This house stood previously on a tabby foundation but was lowered in the 1930s. Standing on the porch in this 1922 photograph are, from left to right, daughters Annie G. Seabrook and Virginia L. Seabrook, Florence "Flossie" Seabrook Boykin, and "Susie" Seabrook. Their cook is standing by the gate. (Photograph courtesy of Annabeth Proctor from Ben and Sally Whaley.)

MR. AND MRS. JOSEPH EDINGS LAROCHE. This photograph shows Joseph "Joe" Edings and his wife, Ella Murray LaRoche, in their living room. Joe was born on April 27, 1835, and died on May 13, 1898. Ella was born on August 8, 1836, and died on August 17, 1917. (Photograph courtesy of Jean Townsend.)

THE JOSEPH EDINGS LAROCHE HOUSE. Elias Bull tells that "the porch, and the house itself, is located about three feet off of the ground. This building is somewhat unusual for Rockville in that it is built near the ground without the usual tabby foundations. This house is built from a utilitarian standpoint to receive the maximum amount of air and light by the spacing of the windows and its orientation to the prevalent breezes from the south, which it faces." (Photograph by Elias B. Bull; courtesy of Charleston County Public Library.)

DANIEL JENKINS LAROCHE. Daniel owned the last piece of land on the western edge of the village and built a house on it around 1842. On September 19, 1872, Daniel wrote to Julian Mitchell regarding the title to the Rockville house and lot and the payment of $50 for the use of LaRoche's new steamer to float the house around to New Cut Plantation, located on the other side of Wadmalaw. He needed it done as soon as possible because he had to get his cotton picked. The third hall was then built on this property, and the surrounding marsh was filled in for parking. (Photograph courtesy of William Jenkins Seabrook.)

THE EDWARD D. BAILEY HOUSE. Master builder Edward D. Bailey built this house in 1853 or shortly afterward. It is noted for its fine construction and is probably Rockville's finest example of architecture. This two-story clapboard house has a first-floor veranda and six Tuscan columns. The house is also known as the Merle Whaley House after one of the longest-lasting village schoolteachers, Merle Batson Whaley. There was a report that this house served as a hospital during the War Between the States and that Belle Seabrook ran a post office from the second floor after the war. (Photograph by Elias B. Bull; courtesy of Charleston County Public Library.)

THE PAUL STANLEY MCCHESNEY HOUSE. Reverend McChesney built this house for his new bride, Blanche Townsend McChesney in 1910. Blanche's mother, Mary Amarinthea, gave her the property. In the late 1900s, this house was redesigned and lowered by architect George Seabrook, who added a porch (on the left) to the side of the house, and then converted the porch into a room.

THE REVEREND PAUL STANLEY MCCHESNEY FAMILY. Pictured here from left to right are: (first row) Hugh McChesney and his cousin, Evans Townsend; (second row) Rev. Paul S. McChesney; his daughter, Mary McChesney; his wife, Julia Blanche Townsend McChesney; his other daughter, Claudia McChesney; Mrs. Mary A. Townsend; and his son, Samuel McChesney. Reverend McChesney was the minister at the Rockville Presbyterian Church from 1908 until 1912. He married Julia on June 30, 1908, in the sanctuary of the Rockville Church. (Photograph courtesy of Jean Townsend.)

DANIEL AUGUSTUS STEVENS. "Gussie" was the son of Capt. William Yates and Virginia W. Bailey Stevens. He attended Porter Military Academy and then North Carolina State College, married Agnes Wilkinson LaRoche, had two daughters, and died on December 26, 1988. He and his brother, Constantine ("Con"), ran his father's steamer company, Stevens Line. Once bridges were built and trains were replaced by trucks, he converted the steamers into shrimp boats. After Hurricane Gracie, he moved his docks from the middle of Rockville to Cherry Point. (Photograph courtesy of Dellie Eaton.)

AGNES LaROCHE STEVENS. "Agie" was born on September 29, 1905. She married Gussie, and they had two daughters, Lydelle LaRoche Stevens Eaton and Augusta LaRoche Stevens Seabrook. She died on January 16, 1986. She was the daughter of Micah John LaRoche and Talloulah W. Wilkinson LaRoche. (Photograph courtesy of Dellie Eaton.)

THE HAMILTON SEABROOK WHALEY HOUSE. Bates Wilson and Oliver Frances Seabrook built this house between 1920 and 1925. Harry Townsend did most of the painting. Siblings John and Margaret Whaley inherited the property from their uncle, Hamilton, whose brother and sister-in-law, Claude and Mary Merle Batson Whaley, lived next door. Currently Jimmy and Linda Folk own it.

THE SCOTT BAILEY HOUSE. This house was built in 1888, and at that time, it was only a small one-story house. John Bentz Jr., Sinkler Warley, and J. D. Bryant have owned it through the years. At some point or another, Mary Emily "Dapper" Rivers Seabrook lived here. Her daughter, Olivia Florence, who married John Scott Bailey, also lived here. The home is now owned by Benjamin and Sarah "Sally" Florence Bailey Whaley.

THE JOHN BAILEY FAMILY. Shown here from left to right are (standing) John Berwick Bailey and his wife, Florence Seabrook Bailey, whose face is unfortunately obliterated; (seated) her mother Belle Crawford Seabrook and his mother, Fannie Bailey. The two children are (left) Julius Charles Townsend Jr., son of Julius Charles and Mai Seabrook, and (right) Bonnie Bailey, daughter of John Bailey and Florence Seabrook Bailey. (Photograph courtesy of Jean Townsend.)

THE PRESBYTERIAN MANSE. Elias Bull tells that this house was "built for Mrs. Belle Crawford Seabrook shortly after she acquired it in 1903, this rectangular wooden building is built about three feet off the ground on brick pillars. Its real significance lies in the fact that for twenty-six years it was used as the Presbyterian Manse of the Rockville Presbyterian Church. Prior to and since then, the Presbyterians have been without a manse on the island of Wadmalaw." The Reverend Theodore "Gunner" Ashe Beckett, his wife, Elizabeth Scroggs, and daughter, Mary Beckett Townsend, who married Edward Henry Townsend, lived in the house for many years. (Photograph by Elias B. Bull; courtesy of Charleston County Public Library.)

ROCKLAND PLANTATION'S OVERSEER'S HOUSE. The oldest plantation is listed as Rockland Plantation, dated 1800, and consisting of about 760 acres. Records show that Dr. Daniel Jenkins Townsend bought Rockland Plantation in the early 1800s. Elias Bull says that "This is the only plantation overseer's house in Rockville, and it probably was built for William Seabrook when he acquired the plantation upon which the village of Rockville stands today. It is also the only building put together with pegs." (Photograph by Elias B. Bull; courtesy of Charleston County Public Library.)

THE FRONT OF THE OVERSEER'S HOUSE. Elias Bull says that this "building was originally rectangular in shape, with a one-room, one-story addition to the rear. Numerous additions were made, all of them after 1865. The plan of this original part of the house is that of a small hall containing the stairwell in the center with semi-octagonal rooms on either side and three rooms across the back. The second floor, the back part of which was added later, repeats this same design. This back area has a shed roof. Another chimney is outside to the east at the back." (Courtesy of Charleston County Public Library.)

JAMES SWINTON TOWNSEND. "Swinton" was born at Fenwick Hall on John's Island on September 16, 1849. He married Mary Amarinthea Jenkins Townsend on December 11, 1871, and had 10 children. His father, Dr. Daniel Jenkins Townsend, gave Swinton 400 acres in 1860. When his father died, he left Swinton the other 360 acres of Rockland Plantation, which that they had farmed together. After the war, Swinton found it difficult to manage Rockland Plantation alone, so unfortunately, he had to mortgage 400 acres after the first year. They lived in this old overseer's house. In 1885, he lost those acres and died shortly after his last child was born on December 16, 1887. (Photograph courtesy of Jean Townsend.)

MARY AMARINTHEA JENKINS TOWNSEND. "Mamie" was born on September 6, 1849, married James Swinton Townsend, had 10 children, and died on July 11, 1937. Kate McChesney Boll states that Mamie's "husband died intestate, leaving the house and 360 acres of land. About ten Negro families were living on the place rent free expecting a living from the owner. For the rest of her life, Mary struggled trying to make ends meet." (Photograph courtesy of Jean Townsend.)

SOPHIE AND BILL JENKINS. Sophie Jenkins explains, "We were cousins, Bill and I, our fathers being first cousins; on my maternal side, his father and my grandmother were first cousins. Through the Jenkinses and LaRoches, Bill and I were closely related. We lived on Wadmalaw Island on plantations hardly five miles apart; and yet because of the time when the South had hardly recovered from the war of the sixties and Reconstruction of the seventies, when roads, public or otherwise, were still dirt roads, and the horse provided the means of transportation, plantation families saw little of each other. Prior to about 1914, I can only remember seeing Bill about twice." (Photograph courtesy of William Jenkins Seabrook.)

THE CHARLES E. FRIPP HOUSE. Plantation owner, Charles E. Fripp acquired this property in 1835 and promptly built this house. Historian Elias Bull states that "Its original appearance is unknown, since William Hamilton Jenkins remodeled it probably in the 1930s. The building is about three feet off the ground and is built in a shape of a rectangle with a one-room, one-story addition in the rear, which extends the length of the house. This addition has a shed roof. The building proper is two stories tall with one chimney offset on the west rear roof." (Photograph by Elias B. Bull; courtesy of Charleston County Public Library.)

THE CHARLES E. FRIPP HOUSE. The half-acre lot just behind the rectory was sold by John C. Wilson to Charles E. Fripp of Johns Island. Wilson had originally purchased the lot from William Seabrook of Edisto Island. In 1855, the widow Fripp, by deed, described it as that "lot of land lying and being at the Rocks, or Rockville, Wadmalaw Island." William C. Bailey acquired the lot next and then sold it to Joanna Denaro in 1874. Joanna Denaro sold the land to her granddaughter, Alice Glen Whaley Bailey. Sophie Jenkins and her husband, Bill, bought it from her, renovated the house, and later sold it to R. D. Jury. Jury also bought Horse Island, located on the other side of Bohicket Creek. (Photograph by Elias B. Bull; courtesy of Charleston County Public Library.)

ROCKVILLE'S ANCIENT PECAN ORCHARD. This pecan orchard could possibly date back to 1776, when Thomas Tucker and his wife, Mary, sold their 496 acres of land to Benjamin Jenkins. Orchards were mentioned in the deed, and it has been written that there were pecan and cherry orchards in the village. The names of the northern and far eastern sections of Rockville, Cherry Point and High Cherry Hill, both lend credence to this thought.

THE BAILEY FAMILY. Pictured here from left to right are (first row) Florence "Foggy" Seabrook, Alonzo Francis "Tunny," Ann "Nan" Crawford, and John Barnell Bailey; (second row) Mai Seabrook, John Berwick, Florence Belle Seabrook, and Alvina "Allie" Legare Bailey. Tunny got his nickname from a 1926 favorite heavyweight champion, John Tunney. (Photograph courtesy of Annabeth Proctor.)

ALVINA LEGARE BAILEY CATES. "Allie" was born on November 2, 1905. She married Oatis Marshall Cates; had two children, Francis Berwick Cates and Shirley Cates Meares; and died on April 17, 1995. Her house was located across from the Green and next to Dr. Barnwell's house. Allie was the daughter of John Berwick Bailey and Florence Belle Seabrook Bailey. (Photograph courtesy of Emily Leland.)

THE EDWARD HENRY BARNWELL HOUSE. Dr. "Harry" Barnwell was the village doctor for many years. His house was across the road from the old schoolhouse. He had his own doctor's office behind his house in Rockville. Harry was the son of Gabriel Henry and Elizabeth Thomson Marshall Barnwell. He was born on January 4, 1878, married Sarah McLeod Bailey on July 15, 1903, and had six children. His second wife was Rose Lulah McLeod. Dr. Barnwell was buried at St. John's Episcopal Church on January 27, 1967.

THE ELEANOR BAILEY HOUSE. This house was built about 1920. The first house on this lot belonged to William Reynolds and Mary Love Jenkins but was later torn down. Sarah and Charles Townsend, who later moved to Florida, built this second house. Alonzo Francis and Eleanor Bailey lived in this house next after they were married in the 1930s. Villager Annie Batson explains in one of her stories, "My very earliest recollections are of the home my father, Willie E. Jenkins, built on what is now the Bailey property. This house was sold in August 1906, to Mrs. Florence Bailey for $275.00."

THE JOSEPH SOSNOWSKI HOUSE. Josephine "Josie" Edings Sosnowski's husband was Joseph Stanislaus Sosnowski. Josie E. Sosnowski sold this property to Florence Mabel "Maybelle" Boykin for "$5.00 and other valuable considerations" in 1923. This house was just a shell until Maybelle's second husband, Thomas Andrew Jamison, did the inside tongue-and-groove walls and most of the needed repairs.

JOSEPH STANISLAUS SOSNOWSKI. Joseph was born on May 16, 1871; married Josephine Edings; had two children, William Sosnowski and Joseph S. Sosnowski Jr.; and died on June 20, 1931. His parents were Grace Townsend and Julius Christian Sosnowski. The Sosnowski family came to America from Poland through Salzburg in 1838 and to South Carolina in 1845.

THE BOYKIN FAMILY. Florence Mabel "Maybelle" Bailey Boykin purchased this house from Josephine "Josie" Edings Sosnowski in 1923. Maybelle was the librarian of the Rockville Branch of the Charleston County Free Library. Pictured here from left to right are: Maybelle's son, Stephen Madison Boykin III; her husband, Stephen Madison Boykin II; her daughter, Florence "Flossie" Seabrook Boykin; and Maybelle. This picture was taken about 1913, before their last two children, John Scott Boykin and Mabel Bailey Boykin, were born. (Photograph courtesy of Annabeth Proctor.)

BROTHER AND SISTER. John Scott Boykin and Mabel Bailey Boykin were the last two children of Maybelle and Stephen Boykin. John Scott was born on April 10, 1918, in Rockville, married Elizabeth Mildred Mary "Millie" Pinckney on March 27, 1943, and died on September 7, 2004. Mabel was born in Rockville on July 10, 1925, married Peter Edward "Bubba" Proctor on September 18, 1943, and died on February 26, 1994. Mabel was angry with her son one day and ripped this picture into four pieces. Luckily she taped it back together. Mabel was also the librarian of the Rockville Branch of the Charleston County Free Library. (Photograph courtesy of Annabeth Proctor.)

TWO BROTHERS IN MILITARY UNIFORM. This photograph, taken about 1943, shows Peter Edward Proctor in his army uniform and his brother, William "Big Boy" Grady Proctor, in his navy uniform standing in Maybelle's backyard. (Photograph courtesy of Annabeth Proctor.)

STEPHEN EDWARD PROCTOR. Stephen is the son of Peter Edward and Mabel Proctor. He is standing in his backyard at four years of age. He has a brother, Donald Herbert, and a sister, Mabel Elaine. (Photograph courtesy of Annabeth Proctor.)

THE CHARLES GRIMBALL WHALEY HOUSE. Charles Grimball Whaley and his wife, Julia Evelina Whaley, bought this house in the early 1900s. Their daughter, Mary Eva Whaley, married Mark Tolbert. Unfortunately this house burned to the ground on January 22, 1984. (Photograph by Elias B. Bull; courtesy of Charleston County Public Library.)

MARY EVALINA WHALEY. Mary Eva Whaley was the daughter of Charles Grimball Whaley and his second wife, Julia Evelyn Bailey. Mary Eva was born on June 15, 1901, in Rockville, married Mark Pope Tolbert on May 3, 1928, had four children (two died as infants), and died on September 20, 1972. Mary Eva drove a Charleston County school bus for years. Mark died on January 22, 1984, when their home burned to the ground. His grandson, Mark Pope Tolbert III, lived nearby in the Rockville schoolhouse for many years. (Photograph courtesy of Annabeth Proctor.)

THE CHESTER PERRY HOUSE. About 1904, a simple summer home was built by Mr. and Mrs. Charles Frank Davis, but they only used it for a few summers. Thanks to the Works Progress Administration (WPA), local ladies were able to earn a small income during the Depression by sewing in this house. At one time, Sheriff Chester Perry lived in this house. This house once had a front porch.

THE LEGARE HOUSE. Two spinsters, Viola and Rosa Legare, lived in this house for many years. After they died, Rosa and Edings Whaley Wilson, brother of Bates Wilson, lived here for a period of time, as have Charles Auditore, Betty Elizabeth Polzin, and Mr. and Mrs. Saul Gliserman.

THE JOSEPH POPE BAILEY HOUSE. Mary "Mamie" A. Whaley and Joseph Pope "Polar" Bailey may have built this house around 1902. It was then bought by brothers Hamilton Seabrook Whaley and Charles Joseph Whaley. Charles's son, Charles Jr., was killed during World War II in Alabama, so his daughter, Elizabeth, and her mother, Lila Skinner Whaley, lived in the house. Lila's father was the Reverend Frederick Nash Skinner, who served St. John's Episcopal Parish from 1918 to 1926. Later Charlotte Jenkins and her mother, Theodora "Miss Theo" Jenkins, lived in the house.

THE JOSEPH POPE BAILEY HOUSE. It is not clear who built this house, but Elias Bull states that the builder "erected a fine home by taking one of the basic Rockville house plans and improving on it. Since this house stands in the third row of houses back from the waterfront, he built his house with a double-tiered porch to catch the maximum amount of moving air, so necessary for survival in the hot and humid coastal area." (Photograph by Elias B. Bull; courtesy of Charleston County Public Library.)

GEORGE WASHINGTON SEABROOK. "Washington" owned an antebellum house that no longer stands. It was located on the east side, next to a lot owned by Susan Townsend.

DR. AND MRS. JAMES CLARK SEABROOK. James and Martha Evelina LaRoche Clark Seabrook were married in 1855 and celebrated their 50th wedding anniversary on April 26, 1905. Martha, daughter of Richard LaRoche and Martha Seabrook Jenkins, was born on October 27, 1836. James Clark was born October 11, 1830. The Seabrooks had four children—Oliver Washington, Martha Louise, Francis LaRoche, and James Clark Seabrook. They too owned an antebellum house and lot that no longer exists, located behind Washington's lot.

Two

Grace Chapel and the Rockville Presbyterian Church

The Rockville Presbyterian Church. With the difficulty of retaining ministers willing to stay so far away from the city of Charleston, the two village churches would often take turns having religious services. Church members gratefully became ecumenical; for whichever church had the good fortune of having a minister, theirs was the one to attend. Often the youth of the parish would attend each other's Sunday schools. The adults were happy to just be able to worship God near their summer homes. From their earliest conception, if one denomination's church burned, was in need of repairs, or was under construction, the other would permit services in its own sanctuary. There have been numerous thank-you notes recorded in each of the parishes' register minutes. This photograph was taken from the Townsend house after the Hurricane of 1893. (Photograph by Ned Jenkins; courtesy of Jean Townsend.)

GRACE CHAPEL. In 1838, Rev. Thomas John Young proposed a plan to the vestry of St. John's Episcopal Church on John's Island to collect funds for a chapel-of-ease for St. John's parish. This chapel would serve the residents of Edisto, Wadmalaw, and John's Island. The vestry estimated costs to be approximately $1,500, and by July 1840, the chapel was completed. It first occupied a lot located behind the home of Mrs. William E. Jenkins. After the War Between the States, Ferdinand Schaffer acquired the chapel and property and offered to exchange lots for one that was on the water. In 1885, the title of the lot was proven uncertain. Schaffer allowed the Episcopal ladies of Rockville to have the chapel, so it was rolled 500 feet on palmetto logs to its present location on a nearby lot given by Elizabeth Frances Jenkins.

HORSE AND BUGGY. Traveling among the Sea Islands was difficult during the horse-and-buggy days of the 19th century. Only by using horse carriages, carts, riverboats, and steamers could local ministers conduct their normal routine of having early morning services at the larger, inland parish churches and evening services at one of the two churches in the village. Annie Batson explains that "village life was really quite simple long ago. We were completely cut off from the city except by boat, so life centered around the home, the church, and the school. Village roads were wide enough for a horse and buggy and some were only lanes." In this photograph, Grace Seabrook and a cousin are probably traveling either to Sophie's house or to the school in Rockville.

GRACE CHAPEL. In 1876, during his time as minister in the parish, the Reverend George W. Stickney gave the name, Grace, to the chapel. Elias Bull tells that "the Chapel, is a rectangular wooden one-story building built close to the ground. A short flight of wooden steps leads to a porch, which extends along the entire width of the front of the building. In the center is a double door built in the Gothic style. It is flanked by two Gothic windows, which are covered by hinged, slatted double shutters. The porch is supported by four plain posts, which are supported at their bases by three-foot brick pillars. Although the belfry and porch are products of another style of architecture, they harmonize will with the essential Gothic character of the building proper. The interior continues the charm by the use of brown stain on the wooden walls, the pointing of the grooves in the boards to center attention toward the chancel area, which is highlighted by a small stain glass window." (Photograph by Elias B. Bull; courtesy of Charleston County Public Library.)

STAINED-GLASS WINDOW DRAWING. After the 1886 earthquake, Grace Chapel was left barely more than a shell of a building. Clara Barton, from the newly formed Red Cross, visited Rockville and met with the villagers in Grace Chapel. This hand-sewn, pencil drawing was done by William E. LaRoche in June 1890, when the chancel was built onto the chapel. The Reverend Barnwell Bonum Sams came to the parish in 1895; under his pastorate, the young men made the necessary repairs and lined the interior with wood paneling. Bishop Ellison Capers consecrated Grace Chapel on January 6, 1898. During the rectorship of the Reverend Henry deC. Mazyck, a new altar was installed and the chapel was given a new porch and belfry. Joseph Seabrook Hart gave the chapel a bell, and Mrs. Joseph Jenkins Wilson collected money for a new organ.

GRACE CHAPEL'S STAINED-GLASS WINDOW. After the terrible Hurricane of 1893, an anonymous donor gave funds for many small chapels in the South to have Tiffany stained-glass windows installed once they had rebuilt their churches. Grace Chapel received a window that matches a Tiffany stained-glass window in the church at the U.S. Naval Academy in Annapolis. William E. Jenkins placed the window behind the altar about the same time the new altar was installed. (Information from Sandy Bee.)

Richard Jenkins LaRoche. "Dick" was born on June 20, 1820, and died on October 20, 1893. He first married Elizabeth Elvyra Jenkins, and after she died, he married Mary Caroline "Lena" Townsend. This tintype photograph shows Richard Jenkins LaRoche in a formal pose. He lived on Edisto Island but often commuted to Rockville to stay in his house, which was located next to John F. Townsend's house.

Mrs. Richard "Lena" Jenkins LaRoche. Mary Caroline "Lena" Townsend was born on September 27, 1842, married Dick LaRoche, and died on August 29, 1928. She was very instrumental in raising peoples' interest in church projects and funds to complete them. By 1888, after writing many letters to churches east of the Mississippi, Mrs. Richard Jenkins LaRoche was successful in securing a lectern and a pulpit from Flint, Michigan. Both she and her husband were pillars in the community.

RICHARD JENKINS LaROCHE. Richard did so much for so many people. When St. John's Episcopal Church burned in the spring of 1864, he camped out, bought materials, and helped rebuild the church.

GRACE'S PULPIT AND LECTERN. This letter of shipping is from G. L. Denham at the Office of City of Flint Gas Light Company in Flint, Michigan, on August 30, 1890, to Mrs. R. J. LaRoche of Edisto Island, South Carolina: "Madam, Your favor of 20th last was duly received. I have had the pulpit and lectern crated and shipped the same to you today as per enclosed R. R. receipt and hope they will reach you in good order. Freight prepaid $3.89. The rate of freight is more than they told me when I inquired before, but the weight of the package is much less than I estimated so that as the whole the cost will be less than I wrote you, Yours respectfully, G. L. Denham."

LENA LAROCHE. Lena wrote to many churches when she was trying to replace Grace Chapel's furniture. Once she was successful in obtaining the furniture from a church in Michigan, Lena wrote, "That we are really to have a Pulpit and Lectern seems almost too good to be true! I can only say again I thank you. I thank your Rector and Vestry: and you personally for your willing optimistic action in the matter. The furniture will probably reach us by today's boat. Yours respectfully, Mrs. R. J. LaRoche."

WETHERHORN AND FISCHER'S RECEIPT. This receipt was for materials used to make repairs to Grace Chapel after all the years of storm damage. The materials were sold to R. J. LaRoche on April 22, 1890. Wetherhorn and Fischer's sold general building materials and was located in Charleston on Smith Street.

GRACE CHAPEL. Grace Chapel is used mostly for services in the summer months. In the past, some ministers at St. John's have had regular fifth Sunday services here. There have been numerous small-family weddings in the chapel, where uninvited canine guests routinely check out the situation.

DR. JOHN FERRARS TOWNSEND III. John was born on April 22, 1880, married Sarah Harleston Ball, and died on January 31, 1962. John's namesake and grandfather often gave his time, talents, and money for church projects. It has been reported that his grandfather financed the project of building the Rockville Presbyterian Church.

THE ROCKVILLE PRESBYTERIAN CHURCH. Blanche Townsend McChesney tells that in 1837, her grandfather, Dr. Daniel Jenkins Townsend, "had two of the slaves apprenticed in Charleston as carpenters, etc. and started to build a church nearby. It was modeled after the St. Michael's Church with a high steeple. It was high from the ground, big porch, two doors, and high steps. The windows were in groups of three, three groups on each side and one group on either side of a high pulpit. There was a gallery in the back for the negroes. It was beautifully done. It had 'tabby work' pillars. This was his summer church." (Photograph by Elias B. Bull; courtesy of Charleston County Public Library.)

NEW YORK, NOVEM[BER]

ROCKVILLE, A DESERTED VILLAGE NEAR CHARLESTON.—FROM A S[KETCH]

21, 1863.

BY OUR SPECIAL ARTIST, W. T. CRANE.

THE ROCKVILLE PRESBYTERIAN CHURCH STEEPLE. This is the only known image of the Rockville Presbyterian Church's steeple. W. T. Crane drew it about 1863 during his travels around the area as an artist for *Frank Leslie's Illustrated Newspaper*. Kate McChesney Bolls explains that during the storm of 1893, "It began raining hard and the wind blew water in under the doors and windows. The only room in the house that was not wet was the dining room and as night had come, mattresses and sofas were collected there. I slept a little but was awakened in the night by the ringing in the Presbyterian Church steeple. It sounded as if tolling a knell. Towards dawn we heard a crash. The steeple had fallen on the Church, breaking in the roof and driving some of the pews through the floor. The next day we went to see what had happened around the village. About fifty feet of the bluff along the river had caved into the water. The big oaks along the 'front' were flat and every wharf was gone." (Sketch by W. T. Crane.)

FRONT OF CHURCH. During the War Between the States, Confederate Soldiers used the steeple on the Presbyterian Church as a watch tower. There was a hole in the side wall where a soldier could watch for Yankee ships in the North Edisto River. Blanche Townsend McChesney tells that "when the Union patrols took over Rockville, they used the steeple as a lookout for the Confederate soldiers. It was stated that they shelled the village because of this, but fortunately, there was no damage reported." Rockville fell to the Union forces on December 18, 1861. (Photograph courtesy of Jean Townsend.)

REAR OF THE CHURCH. Annie Batson tells the story about her father, William Evans Jenkins, and the snake. "Someone touched him on the back and whispered, 'Cousin Willie, there is a snake on one of the front pews.' Sure enough, on one of the pews to the front of the dimly lighted church something black twisted and waved in the wind from the open window. My father quickly left the church and went next door for a hoe. Coming back he stood in the aisle and interrupted the minister. 'Excuse me,' he said, 'but there is a snake on the back of that pew.' He marched up the aisle with the hoe and, getting closer, reached up and held out the snake. It was a lady's black veil, which had been taken off by an older lady, Mrs. Mattie Wilson. The congregation almost dissolved in laughter." (Photograph by Elias B. Bull; courtesy of Charleston County Public Library.)

THE OAK TREE. This old live oak tree sits in the yard between Bailey's store and the Rockville Presbyterian Church. This lane, which led to the Townsends' back yard, has been known as Welch's Lane and also Shady Lane. (Photograph courtesy of Jean Townsend.)

CLAUDIA TOWNSEND. Several villagers have stories about "Claude." Annie Batson said that she "was highly intelligent and loved music, art, and creating exquisite embroidery and crochet work. She loved the things that I did—books, poetry, music and out-of-doors. She taught herself to play by ear on the hand organ and piano and played for Sunday school and sometimes for church." She had surgery when she was in her early 30s, and the anesthesia affected her brain. She spent her last years in the state hospital. This photograph was taken in 1914. (Photograph by Jean Townsend.)

JULIA BLANCHE TOWNSEND MCCHESNEY'S WEDDING DAY. Blanche tells in her own words, "One summer when the village was full of people, a young seminary student came down to the John's Island and Rockville Presbyterian Churches. The young preacher, Mr. Mac [Rev. Paul Stanley McChesney], was always around. We saw each other everyday and on June 30, 1908, we were married at the little Rockville church. The groom looked very distinguished in his 'Prince Albert' as we called it then, and the bride's dress, of white with insertion and lace with a long train, was very pretty." She also wore her father's oratorical medal and gift watch that day. (Photograph courtesy of Jean Townsend.)

ANNE FLORIDE RIVERS TOWNSEND'S WEDDING DAY. Floride married Walter Eugene Townsend on October 15, 1907. They moved first to a farm in Mount Pleasant, then to Washington, D.C., from there to Arizona, and then finally returned to South Carolina. He bought the house behind his mother's, which had been built by his sister, Blanche, and her husband. They lived there for many years. Kate McChesney Bolls tells that "Walter was a Deacon in the Rockville Church and an Elder in the James Island Presbyterian Church. He and his wife, Floride, are buried in the James Island Church Cemetery." (Photograph courtesy of Jean Townsend.)

REV. PAUL STANLEY MCCHESNEY. Reverend McChesney was born on May 30, 1881, in southwest Virginia. He enrolled in the Columbia Theological Seminary in Columbia, South Carolina, when he was 24, in the fall of 1905. After spending two years there, he moved to Rockville and supplied the Rockville and Johns Island Presbyterian Churches. Mr. Mac separated the ties between these two churches in 1909. (Photographs courtesy of Jean Townsend.)

MAMIE'S WEDDING DAY. She was 38 years old when she and Edward Whaley "Ned" LaRoche married in 1910. Kate McChesney Bolls tells about her Aunt "Mamie," who was born on September 20, 1872. "Mary Amarinthea 'Mamie' Townsend LaRoche studied nursing at Roper Hospital in Charleston about the turn of the century but became so discouraged when many of her patients died with typhoid fever during an epidemic that she gave up her profession. She married Ned LaRoche and they lived on Merritt Island, Florida, on the Indian River, where they had orange groves. They had no children." (Photograph courtesy of Jean Townsend.)

"DAILY BREAD." Mary McChesney Bushkovitch tells the story of her uncle Walter Townsend and his "daily bread:" "Uncle Walter was full of fun and loved to tease. He knew that every morning before his mother came downstairs, she knelt by her bed and prayed for 'her daily bread.' Many times Walter would yell up the steps, 'Ma, you can get off your knees now. Your 'daily bread' is at the back door.' At the bottom of the steps was a black fisherman with five fish strung on marsh, $.25, and a quart can of shrimp—also $.25." Walter's brother, Julius Charles Townsend, is pictured here with his "catch of the day." (Photograph courtesy of Jean Townsend.)

THE OLD OAK TREE. This tree has withstood the test of time. Many villagers have spent time looking at its large limbs, sitting beneath it, and enjoying its cool shade.

Three

THE VILLAGERS AND THEIR WAY OF LIFE

REUNION DAY, 1900. After the years of Reconstruction, to commemorate their ties, the veterans of the Confederacy for many years held an annual reunion in Rockville around the middle of July. Helen L. Bailey Perry remembers that "a large hall has been erected by them. It is in the centre of the village and is surrounded by beautiful oak trees. In front of it is a grass meadow, which extends almost to the river. Great preparations are generally made by the people of the village. The grounds are beautifully cleared up, and tables and benches are placed under the shade of the oaks. When that eventful day arrives, buggies and carriages may be seen coming down the road, and launches and sailboats are skimming over the water. Everybody's houses are thrown open to welcome the visitors, who come from Charleston and the surrounding Islands." Pictured here is Helen's sister, Mary Olivia "Eva" Bailey, at the reunion in July 1900.

Mary Martha Seabrook. "Mai" was born on January 1, 1883, the daughter of Thomas and Belle Crawford Seabrook. She married Julius Charles Townsend on June 16, 1901, lived at Brigger Hill, had seven children, and died on June 28, 1955. Mai's children were Julius C. Townsend Jr. (Charlie), Thomas Seabrook Townsend (Tom), Edward Henry Barnwell Townsend (Harry), James Swinton Townsend II (Billy), Mary Leslie Townsend Dotterer Jervey (Leslie), and two who died in infancy. (Photograph courtesy of Jean Townsend.)

THREE SEABROOK SISTERS. These three daughters of Thomas Wilkes Seabrook and Alvina Belle Crawford Seabrook are, from left to right, Anna "Annie" Elizabeth Seabrook, Florence "Belle" Seabrook, and Mary "Mai" Martha Seabrook. They all grew up to marry men with ties to Rockville. Belle married John Berwick Bailey, Annie married James G. Palmer, and Mai married Julius C. Townsend. (Photograph courtesy of Jean Townsend.)

GENERATIONS OF TOWNSENDS. Mary Leslie Townsend sits here with her grandmother, Alvina "Belle" Crawford Seabrook, and her brother, Julius Charles "Bummie" Townsend. (Photograph courtesy of Jean Townsend.)

COUNT FERDINAND DE LASTEYRIE. Martha Washington Seabrook, daughter of William Seabrook of Edisto and his second wife, Elizabeth Emma Edings, and niece of Gov. Whitmarsh Seabrook of South Carolina, married Frenchman Count Ferdinand de Lasteyrie in a religious ceremony on May 30, 1846. Count Ferdinand de Lasteyrie was a member of the General Assembly and a Republican member of the Chamber of Deputies. Being married to William's daughter, Count de Lasteyrie was in charge of most of the eastern side of Rockville. After the War Between the States and his death, his family had to go to court to get their family lots returned to them.

DUCHESS OF WADMALAW. Roy Attaway explains Rockville's royalty, "The wonderfully eccentric, Georgiana Horry Palmer Townsend or simply, 'Duchess of Wadmalaw,' was a legend in her own time. An admirer, who after having been previously informed of her outstanding family lineage, wrote a letter addressed to 'Mrs. Georgiana Horry Huger Manigault—ad infinitum—Palmer Townsend, the Duchess of Wadmalaw.' She was so moved by his title that from that moment on, she actually bestowed it upon herself and was forever after referred to as 'Duchess.' Those who knew her tell you she deserved the title. She was a grand lady in the truest sense of the term, matriarch of island society, and never idle." Duchess loved to "put up" produce and was famous for her Duchess-Brand Palmer Palmetto Pickles. In 1937, after King Edward VIII of England abdicated the throne and married the love of his life, Wallis Simpson, Duchess sent them a jar of her famous relish as a wedding present. "To the happy couple," she wrote on the gift card, "from The Duchess of Wadmalaw." (Photograph courtesy of Marianne Stein.)

VILLAGE TEENAGERS. This picture was taken in the Townsends' front yard about 1903. From left to right are (seated) Walter Townsend, Maybelle Boykin, Floride Rivers, Louisa Bailey, Annie Jenkins, and Annie Bentz; (standing) Claude Townsend, Helen Bailey, Susie Seabrook, Francis Stickney, Blanche Townsend, Eva Bailey, and Marilee Stickney. Annie Batson remembers that "best of all were the singing times on the village bench or one of the wharves. On Friday nights usually the teen crowd gathered at the hall on the village green while the older members of the community sat on the side benches and acted as chaperones." (Photograph courtesy of Jean Townsend.)

"THE MERRY SIX." This photograph was taken in 1922 showing six girlfriends out on Seabrook's Beach for the day. From left to right are Agnes LaRoche on the shoulders of her sister, Lydelle LaRoche; Anne Gautier Seabrook; Mary Martha "Mattie" Wilson; and Gertrude "Gertie" Bailey on Frances "Fannie" Josephine Wilson's shoulders. (Photograph courtesy of Emily Leland.)

ON SEABROOK'S BEACH. Seabrook's Beach, once owned by William Seabrook of Edisto and his sons, is a favorite hangout for the villagers. To this day, island residents travel by boat to the most northern tip of the island to Privateer Creek to have much fun in the sun. (Photograph courtesy of Annabeth Proctor.)

AT THE BEACH HOUSE. There was a very large beach house that was hidden in the deep dunes on Seabrook's Beach. These benches in the front of it were used for rest and recreation. Many a good time was had by all.

ISLAND GIRLS. Claude Townsend, Blanche Townsend, and their first cousin, Mary Lee "Marilee" Stickney, pose here from left to right in 1901 in all their finery. Claude was 14 years old and Blanche was 16 years old. Marilee was born on November 11, 1885, and died on February 25, 1966. (Photograph courtesy of Jean Townsend.)

ALMOST THE WHOLE FAMILY. Due to the fact that many women died during or after childbirth, island men would often have two or more wives and two or more sets of children in their lifetime. This photograph came out of a Jenkins family photograph album. (Photograph courtesy of Emily Leland.)

ISLAND GIRLS WITH A PUPPY. This 1903 photograph shows the three girls two years older and with a new puppy. From left to right are Claude and Blanche Townsend and Marilee. (Photograph courtesy of Jean Townsend.)

THE BAILEY FAMILY. From left to right are Louise Bailey Seabrook, Naomi Bailey Welch, Whitemarsh Bailey, Mary Bailey McFadden, and Maybelle Bailey Boykin Jamison. This photograph was taken before 1958 at the Hall. (Photograph courtesy of Annabeth Proctor.)

TAHLOULAH W. WILKINSON. "Loula" was born on November 9, 1879, the daughter of Mary Ida Warren Wilkinson and Edward Giradeau Wilkinson. Edward was born on October 5, 1855, and died on June 3, 1930. Mary was born on January 18, 1857, and died on October 15, 1889. They are both buried in St. Paul's Episcopal Church in Meggett, South Carolina. (Photograph courtesy of Emily Leland.)

TAHLOULAH WARNOCK WILKINSON LAROCHE. This photograph was taken in 1938 when Loula was 59 years old. She married Micah John LaRoche and had three children—Lydelle Jenkins LaRoche, Agnes Wilkinson LaRoche, and Micah John LaRoche Jr. Micah Sr. died on January 22, 1947, and Loula died on May 30, 1964. They too are buried at St. Paul's episcopal Church. Both of her girls married into the Stevens family: Lydelle married Stanyarne Yates Stevens, and Agnes married Daniel Augustus Stevens. (Photograph courtesy of Dellie Eaton.)

AGIE AND GUSSIE STEVENS. In an interview with Martha Bingman, "Mrs. Agnes 'Agie' LaRoche Stevens remembers when electricity first came to the island. She and her husband had just moved to Rockville and were getting established in the seafood business. She relates that in those earlier years, men in the community had to help place a transformer on a pole by means of a hand-operated pulley system. It was either everyone pitch in and help or no lights. She also recalls being very fond of her first electric range. However, frustration came every holiday season when power outages would occur as a result of everyone overloading the system from the preparation of festive foods. She switched over to a gas range to solve this annual inconvenience." This photograph was taken in 1954. (Photograph courtesy of Dellie Eaton.)

THREE ISLAND LADIES. This picture shows, from left to right, "Loula" Wilkinson LaRoche with Inez Giddes King and Loula's daughter, Agie Stevens. Inez's husband, Preston was a first cousin of Agie's husband, Gussie. These three ladies all lived in the village. (Photograph courtesy of Dellie Eaton.)

WILLIE "POTTER" SIMMONS'S HOUSE. Blanche McChesney tells us that "There were about ten houses for the colored folks, not in 'quarters,' but scattered around and about the hill [Cherry Hill]. Each house had its own garden and all the wood they wanted to burn. Most of them had chickens, and maybe a cow or goat." "Potter, an old man who lived at the back of the village, cut wood and milked cows for his meals at each house in the village." Willie, known to most as "Potter" because he "potted" about the village, was married to Elizabeth. He brought produce in for the villagers, cleaned Grace Chapel, and whitewashed the bottom of the village pine trees for Duchess Townsend and several others. The rent for the house was two watermelons a year. This photograph shows Willie on the right and his son on the left drying their laundry on the bushes. (Photograph probably taken by Ned Jenkins; courtesy of Jean Townsend.)

ALONZO FOBBS. Alonzo was born on April 13, 1915; married Florence (maiden name unknown); had four children, one daughter and three sons; and died on June 3, 1988. Alonzo worked as one of the crewman for the Stevenses' shrimp boats and also at Porter Gaud School as a janitor. (Photograph courtesy of Dellie Eaton.)

CHRISTOPHER FRASIER. Christopher was the cook for Dr. James Clark Seabrook of Allandale Plantation. Christopher was born about 1882, a son of Betsy Frasier Fobbs. He married Alice Anderson Frasier, had 13 children, and died in 1939. He and his wife are buried near the village in the Osma Bailey cemetery, also known as Oak Grove. Even today, when in the kitchen, members of the Seabrook family are heard to say, "I wish Christopher were still here!" (Information courtesy of Alice Singleton Slan and Blanche Frasier Gibbs.)

IRENE RIVERS. This picture was taken about 1949. Irene Rivers worked for Inez King and Agie Stevens. She also took care of Ned Seabrook's grandchild, and her son worked for Preston M. King in his store. She was a firm believer in segregation and was totally opposed to integration. (Photograph courtesy of Dellie Eaton.)

93

DELLIE AND GUSTA. Lydelle "Dellie" LaRoche (left) and Augusta "Gusta" LaRoche Stevens originally lived on Yonges Island but moved to the village about 1945. This picture was taken in Rockville when Dellie was in the fourth grade and Gusta was in the fifth. Both these girls married and had children. Gusta married Oliver Francis Seabrook Jr. and had Mary LaRoche Seabrook; Dellie married Carl Gordon Eaton and had Micah David and Elizabeth Alison Eaton. Dellie and Gusta lived in the Paul Stanley McChesney House. (Photograph courtesy of Dellie Eaton.)

HIS 10TH CHILD. James "Swinton" Townsend and his wife, Mary Amarinthea Jenkins Townsend, had 10 children: Mary Amarinthea "Mamie" Townsend; James Swinton "Buddy" Townsend Jr.; Walter and Eugene Townsend, twins who died at infancy; Rosa Melvina Townsend; Julius Charles Townsend; Walter Eugene Townsend, named for the twins; Julia Blanche Townsend; Susan Claudia Townsend; and Henry Evans Townsend. Henry, pictured here with his father, was born on December 3, 1887, at Rockville. Unfortunately Swinton died two weeks after this picture was taken. (Photograph courtesy of Jean Townsend.)

JUDITH KING SUGGS. "Judy" is the daughter of Preston Moore and Inez Giddes King. She married Wilbert "Carroll" Suggs III, had a daughter, Rachel Erin Suggs Black. Judy is the granddaughter of Preston Moore and Evelina LaRoche Bailey King Sr. (Photograph courtesy of Dellie Stevens.)

EUGENIA "JEAN" HILLS TOWNSEND. Here Jean is being held up by her mom, Eugenia Hills Townsend, in the front yard of the Edward D. Bailey House where Claude and Merle Batson Whaley lived. Jean's father was James Swinton Townsend. (Photograph courtesy of Jean Townsend.)

THE ROCKVILLE SCHOOL. Helen L. Bailey relates in a 1906 report on her village school that "the schoolhouse is towards the back of the village. It was very small, but this year the trustees added another room onto it and also engaged another teacher." Later in the small two-room schoolhouse at the back of the village, two island students-returned-teachers—Annie Jenkins Batson and Grace Sosnowski Seabrook—taught the village's children in the early 1920s. (Photograph by Elias B. Bull; courtesy of Charleston County Public Library.)

OLIVER W. SEABROOK. This picture shows Oliver (left) and his cousin, John J. LaRoche. Oliver kept a free school in the village in the late 1890s. Blanche Townsend also taught in the village school and remembers "One day when I was attending that school, the schoolmistress was teaching the infant class the alphabet. When she came to the letter T, one little fellow had forgotten what it was, so in order to help him recall the name, she asked him, 'What does your mother drink everyday for lunch?' The little fellow looked up into her face and answered, 'Whiskey!' Of course we all laughed when he said that. We had expected such a different answer."

VILLAGE SCHOOL CHILDREN. There were three well-known teachers who were instrumental in the lives of the children of the village. Benjamin "Stono Ben" Bailey taught before the War Between the States. Mrs. Frank Whaley (Caroline Cecile "Miss Noonie" Seabrook) taught in the late 1860s, first in the basement of her home in the Micah Jenkins house, and then later in the small school building in the back of the village. A third teacher, Mrs. Claude Whaley (Merle Batson), devoted her life to teaching the three Rs to the village children. She taught the fourth through the seventh grades. (Photograph courtesy of Emily Leland.)

THE WADMALAW SCHOOL. This school was located about five miles from Rockville on Liberia Road. Both teachers, Mrs. Claude Whaley (Merle Batson), left, and Mrs. Harry Townsend (Mary Beckett), right, lived two houses away from each other in the village. Many of these children lived in the village. The students are from left to right (first row) Jimmy Green, Stevie Stevens, Benjamin Whaley, Johnny Whaley, Robert Bentz, Charlie Boykin, John Davis, Donald Proctor, Thomas Townsend, and Fred Fugiel; (second row) Julia Heibel, Constance Townsend, Judy King, Edna Green, Frances Sorenson, Carl Welch, Jay Towles, Jimmy Davis, Sally Bailey, Kathy Fugiel, Kathleen Jenkins, Emily Jenkins, and Linda Davis; (third row) Gay Seabrook, Frances Green, Patricia Jenkins, Diana Heibel, Steve Proctor, Johnny Seabrook, Bubba Jenkins, Derrick Weddle, Virginia Green, Ashley Wilson, Ann Wallen, Emily Fugiel, and Lois Dane. (Photograph courtesy of Annabeth Proctor.)

MARK POPE TOLBERT. Mark is the son of Robert Red and Barbara Parler Talbert and the grandson of Charles Grimball and Julia Evelina Bailey. (Photograph courtesy of Annabeth Proctor.)

FOUR CLASSMATES. Four friends from left to right—Donald Proctor, Johnny Whaley, Charlie Boykin, and John Davis—all went to school together. They are standing beside Charlie's house. (Photograph courtesy of Annabeth Proctor.)

THE STORE AT ROCKVILLE. In front of the Presbyterian church, we find the village store. The Store at Rockville, also known by the villagers as Bailey's Store and then later Harry Jenkins' Store, was supposedly built in the 1880s. Scott Bailey originally ran this store, constructed on Welsh's Lane, and lived in the front house. The next store owner was Henry "Harry" Bailey Jenkins. Harry and his wife, Eva Bailey, lived in the front house, which unfortunately burned in the 1960s. The store served the community until the 1950s and was later converted to a guesthouse.

COUSIN JULIUS'S STORE. Annie Batson tells that "About one mile out of the village down the highway was 'Cousin Julius's Store,' a typical general store with an amazing assortment of things. Orders were shipped by steamboat and landed at the village's wharf." Kate McChesney Bolls tells how Julius Charles Townsend "worked in his youth in the general store for his Cousin 'Jimmie' [James Clark] Seabrook and made fifteen dollars a month. When he married Mai Seabrook, his salary was raised to twenty-five dollars a month. Julius eventually bought the store and worked there all his life." When Julius retired, he sold the store to Thomas Seabrook Townsend, who in turn sold it to Porter Middleton, who moved it a little closer to the village. Today there is a small store right on the outskirts of the village across from Cherry Point Road, which was originally run by Preston Moore King and his wife, Inez. Their son-in-law, Carroll, runs the store to this day.

CAPT. WILLIAM YATES STEVENS. "Captain Bill," son of Daniel Augustus Stevens and Agnes Isabel Yates Stevens, was born at Legareville on John's Island on August 9, 1871. On August 9, 1899, Captain Bill married Miss Virginia W. Bailey, and they later had five children. Captain Bill ran the passenger part of the business, and Gussie and Con ran the Stevens Brothers Company, which was later called Cherry Point Seafood Company. Gussie and Con Stevens moved to Wadmalaw in 1945. They ran the steamer *Mary Draper*; the tugboats *Emily* and *Sunbeam*; and the *Pirate*, which had been a coast guard cutter. (Photograph courtesy of Dellie Eaton.)

THE MIGHTY 13. About 1936, the Stevens brothers; Captain Bill; his sons, Gussie and Con; and their uncle, Capt. Joseph Stanyarne Stevens, bought 13 of these crafts from a retiring Mr. McCabe in Charleston. William Johnson, Con, and Captain Joseph kept up the towing end of the business and the railway under the name Stevens Line. Captain Bill's brother, Stanyarne Yates "Tanny" Stevens, also worked with the boats. A split-up of the Stevens Line occurred about 1943, and Gussie moved his boats to Rockville in 1945 and began shrimping. (Photograph courtesy of Dellie Eaton.)

THE STEVENS BROTHERS. After these brothers moved from the end of the highway to Cherry Point, Gussie (right) and Con Stevens started a seafood company and ran it for many years. Englishman Jimmy Green Sr. helped them run the shrimp boats.

THE WESTOVER. Sophie Jenkins tells about the steamer schedules, "Going to the city, one left Rockville about 6:30 o'clock in the morning, stopping always at Edisto and at a point on the back of Wadmalaw to pick up passengers and freight; then debarked at Yonges Island to take the train to Ravenel, connecting there with the train from Savannah. One arrived finally in Charleston about eleven o'clock, and had then about three hours in which to attend to business, or shop. In the afternoon and early evening, the trip was reversed. It was the custom, especially on summer evenings, to meet the incoming boat, for the boat's arrival was a break in the quiet day of the village. There is a story about two Islanders meeting in the Union Station in Charleston and getting so interested in their conversation that all other matters went by the board and the train left without them." (Photograph courtesy of Dellie Eaton.)

THE WILLIAM SEABROOK. This steamer regularly traveled to Rockville. The houses in the background of this photograph have been difficult to identify. The one on the far left could be the Daniel Jenkins Townsend house, and the one on the far right could be the Episcopal rectory. (Photograph courtesy of Sandy Bee.)

THE SUNBEAM. This powerful steamer was acquired from a Mr. McCabe in Charleston. Pictured here are an unidentified man (left) and Greasy Washington (right). As navigation has changed through the years, the *Sunbeam* was converted from a sailing craft to a hauler of freight. The on-board house that was built later almost covers the entire deck area. During the Rockville Races, the *Sunbeam* was one of the most popular boats. She would be loaded with men, women, and children and would follow the sailboats as they went through their courses. (Photograph courtesy of Dellie Eaton.)

FIRST COUSINS. Dellie Stevens daughter of Gussie, and Stevie Stevens, son of Con, are playing on the *Mary Draper*'s wharf. (Photograph courtesy of Dellie Eaton.)

THE STEAM ENGINE. *Mary Draper* was built in 1869 in Jacksonville, Florida. She carried much produce and numerous passengers through the years. This steamer was later converted to a shrimp boat. Stephen Madison Boykin was her engineer when it was powered by steam.

THE DIESEL ENGINE. This picture shows the *Mary Draper* once it was converted into a shrimp boat with a diesel engine. She docked at the wharf at the end of the road. There were several docks—one owned by Mr. Wells, one by "Captain Bill" (William Yates Stevens), and the other by the Stevens brothers, Gussie and Con. Hurricane Gracie took the docks down and only left one boat, the *Mary Draper*. Gussie's daughter, Dellie Eaton, says, "Unfortunately, Nattie and Victoria Simmons took the 'Draper' out one day to go buy a Billie goat. They hit something in the water, and the boat sank off of Privateer Creek. There it stayed." (Photograph courtesy of Dellie Eaton.)

SEA BUOY. Once during the Depression years, Duchess had a large sea buoy brought up to the house and had the men cut it in half. She had a door cut in the side and used the top half of it as a chicken coop. There her chickens would have a safe place to roost at night.

THE MARY DRAPER'S COFFEE POT. This copper coffee pot was used by Captain Gussie and the crew of the *Mary Draper* and holds an unbelievable amount of coffee. The seamen could get 64 cups of coffee out of this pot!

END OF THE WORLD. Maybank Highway (Highway 700) comes to an end at the docks of the Wells (left) and the Stevens Brothers Company. Wells ran shrimp trawlers out of South Port, North Carolina. Alongside their dock was that of the Stevens Line. Produce was loaded aboard the Rockville boats and shipped over to Yonges Island, to be shipped by rail. To the left of these two commercial wharfs were those owned by E. Bates Wilson. The Stevens's docks were moved to Cherry Point after residents complained of the strong odor. This picture was taken in the early 1940s of Mr. Wells's dock. The two houses in the background are the Osma Bailey House and the Major Daniel Jenkins House. (Photograph courtesy of Dellie Eaton.)

TOWNSEND'S BOATYARD. This picture shows three shrimp boats—*Miss Lorraine*, *Constance*, and the *Susieann*—docked at Adams Creek. James Swinton "Captain Billy" Townsend started this business from scratch. He was born on March 9, 1908, married Eugenia Hill on June 27, 1933, had three children, and died on October 9, 1973. (Photograph courtesy of his daughter, Jean Townsend.)

WORLD WAR II. This photograph was taken before 1958. It shows the village's privy next to Bates Wilson's dock and a tower built on stilts in front of his house. The Coast Guard docked their boats at Bates Wilson's dock. The villagers used this tower during World War II to spot airplanes. At the same time, soldiers enclosed the back porches of the Hall, and it was used as an army barracks. (Photograph courtesy of Dellie Eaton.)

VILLAGE PRIVY. This photograph shows Ginger (left) and Freckles taking a walk on Bates Wilson's dock beside one of the two village privies. The other privy was behind Harry Jenkins's store. Septic tanks were not used until the late 1940s. The rule for swimming in the Bohicket was that you could only swim on an incoming tide. Residents also had to get typhoid shots each summer. (Photograph courtesy of Dellie Eaton.)

THE HALL ON THE GREEN. After the years of Reconstruction, veterans of the Confederacy held an annual reunion of Camp John Jenkins in Rockville every July. In the center of the village they had erected a large hall. Great preparations were made, and when that eventful day arrived, buggies and carriages could be seen coming down the road and sailboats over the water. Everyone's houses were thrown open to welcome the visitors. The railroad boat brought the largest crowd from Charleston. Once sighted, the band on board struck up "Dixie," and everybody went down to the wharves to welcome them. Baskets were sent up, placed under the

care of the table committee, and everybody assembled in the hall. The veterans arranged a few business matters, made a few speeches, and related their experiences during the war. Suddenly the dinner bell would ring, and everyone would go out to the tables with white cloths loaded down with every dainty imaginable. In the afternoon, ice cream was served, and the visitors were shown around the village. At nine o'clock, the dance began, and continued until early morning. It is thoroughly enjoyed by everyone. (Photograph courtesy of Emily Leland; story by Helen L. Bailey Perry.)

THE SECOND HALL. On July 30, 1937, the Sea Island Yacht Club opened a new, 110-by-76-foot, $23,000 auditorium. It was erected on the site of this old dilapidated pavilion located on Breakfast Creek at the west end of the village. The lot was filled in, the rickety dock replaced with a new pier, and dirt was brought in for a causeway and parking. The interior of the new hall has a stage, dressing rooms, open fireplaces, a dance floor and electricity. Annie G. Seabrook is standing in front and to the right of the old hall. (Photograph courtesy of Annabeth Proctor.)

LENA LAROCHE. Lena LaRoche was the wife of Richard Jenkins LaRoche. In this picture, she is standing in the newly built hall, which was later named the Sea Island Yacht Club.

BREAKFAST CREEK. This photograph, taken in 1953, shows three villagers sitting on the yacht club dock. It shows Breakfast Creek in the background as it ran past the Sea Island Yacht Club before the men of the village filled in the section now used for parking. It also shows the creek before Dr. Grier Linton created a causeway to the small island, shown on the left in this photograph. This island has been considered part of Rockville since 1776, when Thomas Tucker mentioned it in his sale to Benjamin Jenkins. (Photograph courtesy of Dellie Eaton.)

SHERIFF CHESTER PERRY. Pictured here on the steps of the Sea Island Yacht Club is Sheriff Chester Perry (second man from the left), born on October 6, 1897, in Charleston to Arthur William Perry and Beatrice Towles Perry. He owned a house in Rockville; loved to sail his boat *Louise*, named after his daughter; and even served a term as commodore of the yacht club. Chester Perry remembers one of the rowboat races when his arms were almost pulled out of their sockets trying to stay abreast of the youngsters who whizzed past him. The pranksters stood laughing on the bank and on nearby anchored boats. Perry did not discover the two large cans tied to the stern of his boat until several minutes had passed. (Photograph by M. Paine.)

OLIVER W. SEABROOK. In connection with the races, it should be mentioned that when "The Green's" lot was sold to the Wilsons, two Edistonians, E. Mitchell Seabrook, and Oliver W. Seabrook gave the lot at the west end of the waterfront to the villagers for the clubhouse now known as the Sea Island Yacht Club. Daniel Jenkins was an owner of this lot around the early 1840s. Oliver W. Seabrook lived his later years on Allandale Plantation a few miles up the road from the village.

Four

THE ROCKVILLE RACES AND THE SAILORS

THE UNDINE I. In the summer of 1890, two cousins, John F. Sosnowski and Isaac Jenkins Mikell of Edisto, put their boats to the test. These two men brought two boats, Jenkins' *Mermaid* and Sosnowski's craft, the *Undine* (meaning one of a class of fabled female water spirits who might receive a human soul by marrying a mortal). The *Undine* was a gift from his uncle, Jimmie. James "Jimmie" Clark Seabrook was the captain of the Wadmalaw entry for the next 20 years after having sailed in that first race with Sosnowski. Gerdeaux Murray was the captain for Jenkins Mikell's boat, *Mermaid*. The winner of that race and the names of the crew have been forgotten. What is more important is that these founders recognized the possibilities of the competitive spirits among their families and friends, which would continue for years to come. (Photograph courtesy of Sandy Bee.)

SPECTATORS FROM THE CITY. In the early 1900s, steamers like the *Surprise* would bring city guests to Rockville to celebrate the annual Rockville Regatta. Rockville was the site of many annual Confederate reunions. As the veterans got older, the sailboat races began to take their place. This annual event in the village brought the regions young and old and kith and kin together for three days of racing, sailing, dancing, romancing, and conversing. Each generation of attendants has their own unique memories of races past. (Photograph courtesy of Sandy Bee.)

THE CREWS. The crews were usually high school or college students who were dedicated to winning the silver for their island. They would often sail all night to get to the regatta. The residents of each island supported their boat and would help build, make repairs, or race them. (Photograph courtesy of Dellie Eaton.)

THE STARTING GUN. On August 5, 1958, the *News & Courier* reported: "Billy Townsend (center) sets himself to fire a starting gun, and the little boy, Bummie Townsend, in the left foreground stops his ears to avoid the shock. Charles Townsend (wearing the cork helmet) and Josh Prioleau wearing skipper's cap, both members of the sailing committee, are seated under the tree." (Photograph by M. Paine; courtesy of Jean Townsend.)

WHAT A CREW! These men are probably standing on the Wilsons' dock. From left to right are Daniel Quigley Towles; Oliver Francis Seabrook, skipper of the *Undine IV*; Edwin Bates Wilson; and Henry Bailey Whaley. (Photograph courtesy of Annabeth Proctor.)

HARRY TOWNSEND AND OLLIE SEABROOK. These best buddies often got together at race time or anytime, as a matter of fact. Harry (left) would often crew for Ollie on the *Undine IV*.

THE LIZZIE BEE. The year was 1899, and James Island came to Rockville with a new entry, the *Lizzie Bee*, which was named for Commo. Sandiford Bee's daughter, Elizabeth Bee. Franklin P. Seabrook, Capt. George R. Seabrook, Reynolds Jenkins, and Sandy Bee built it, and Captain George sailed it for a number of years. The *Lizzie Bee* and the *Undine I* were in constant competition for trophy cups. (Photograph courtesy of Sandy Bee.)

FLAG, 1901. In the year 1901, James Island brought over the first trophy. The James Island Yacht Club ladies made and donated a blue-and-white flag as part of the winner's trophy. This flag was made of blue silk and was embroidered in white, as these were their racing colors. Minnie Bailey Berntheisel tells that "spirit ran high in those days, and every lady, even to the smallest child, wore ribbons the color of her club on her dress or tied around her arm." The *Undine* won it that year, and Oliver Francis Seabrook kept the flag in his possession until 1949. The flag was displayed at Rockville's Centennial Regatta in August 1990 and now hangs in the James Island Yacht Club.

WALTER EUGENE TOWNSEND. Walter, who was named for his twin brothers who had died before him in infancy, built some of the *Undine* sailboats. In an interview by Henry Cauthen about the creation of the *Undine IV*, Walter said that they had built her during the winter nights in the clubhouse. They had to tear part of the wall to get her out. His nephew, Oliver Seabrook, and some of the other boys had helped. (Photograph courtesy of Jean Townsend.)

THE UNDINE IV. In the fall of 1899, the *Undine IV* was cut down into a flat, diamond-bottom, or V-bottom boat. The round-bilge bottom boat was too heavy, clumsy, and sluggish, so they cut away her bottom, leaving the three top planks of her side. The cut-down boat proved to be very fast. The scow was modified and improved, and the Class A scow was replaced by the double-bilge board design—a faster and more maneuverable boat.

A Beached *Undine IV*. On August 6, 1931, the Rockville Regatta ended with protests. The *Evelyn* of John's Island and the *Undine IV* of Rockville were contending for a cup that had been in competition since 1911. The *Evelyn* had won in 1929 and 1930; the three successive victories would give her permanent possession. The new *Undine IV* won all three of the races at this regatta, but it went to trial and was ruled to not be a typical scow in every detail. The cup was awarded to the *Evelyn*.

Ollie's *Undine IV*. In 1947, Ollie Seabrook took the best features of three of the fastest and best sailing scows and gave them to Henry A. Scheel in Mystic, Connecticut, for him to create a set of plans that each island club could use to build a uniform sailboat. This three-man scow was named the Sea Island One Design, and it united the area yacht clubs, allowing for equal competition among the members to this day.

119

PHOTO FINISH. Sometimes the sailboat races were difficult to call—buoys drift, officials make bad calls, and sailors make mistakes. This photo finish was a topic of much discussion. Number 1, the *Matt III*, was 10 feet ahead of *Val Kyrie*, number 8. The committeemen gave the white flag

finish to number 8 for where they stood, based on the angle of the finishing line (a tree and a buoy), the *Val Kyrie* won, but both boats were timed at 1:17:50. M. Paine took this photo on July 27, 1939. (Photograph courtesy of Dellie Eaton.)

OLLIE'S OTHER GIRLFRIEND. Ollie and Peggy's daughter-in-law, Mary Agnes Seabrook, relates Peggy's dilemma: "The early years of their marriage found Ollie toiling in the fields during the day. However, his real labors began in the evenings when he and his cousin, Walter Townsend would go down to the hall in Rockville, where they began building the 'Undine IV.' "Peggy" [Margaret Irving Palmer] would either sit at home with the older ladies and knit (which wasn't her speed) or go with Ollie down to the hall. She has always said that it was a good thing she had a fur coat in her trousseau since she spent her freezing honeymoon nights watching Ollie with the 'Undine IV,' his OTHER girlfriend."

ANNUAL REGATTA ENTRY FORM. This entry card was sent to the Sea Island Yacht Club in 1934 from the Carolina Yacht Club. Oliver Francis Seabrook entered his sailboat, the *Undine IV*, built by his cousin, Walter E. Townsend. The Sea Island Yacht Club was originally formed on August 2, 1905, and was chartered on August 2, 1910. The Wadmalaw Island Yacht Club, written at the bottom of the form, existed from 1902 until 1907.

122

GO OLLIE! Ollie Seabrook is cheered on by his wife, Peggy. Peggy would often tell her tale of meeting Ollie. "In 1925, at age of 16, I came from 10 Water Street to visit my friend Mary Leslie Townsend in Rockville for the regatta. As part of the weeklong race festivities, dances were held every night. I had been to the first two dances with LaRoche Wilson, and it was simply unheard of to go to three dances with the same fellow. I felt doomed to plead sick, when at that moment, the best looking man I have ever laid eyes on, walked up. I thought to myself, 'He's the man I want to marry.' He introduced himself as Oliver Seabrook, better known as Ollie." Peggy got her wish, and six years later, she and Oliver were married on January 24, 1931. (Photograph by M. Paine.)

OLLIE SEABROOK AND FAMILY. This photograph was taken about 1942 on Seabrook's Beach. From left to right are (first row) William "Bill," Margaret "Peg," and Alicia Seabrook; (second row) their parents, Ollie Seabrook and Peggy Seabrook, and Ollie's sister, Grace Sosnowski Seabrook.

A TEACHER AND HER CREW. In this photograph, Mary Townsend sits up front as her brother-in-law, Billy Townsend, skippers his sailboat and young crew. Her nephews, Gilly Dotterer (left) and Bummy Townsend, are learning the ropes. (Photograph courtesy of Jean Townsend.)

THE MATT II. Bates Wilson built the *Matt II*, and he and Billy Ravenel sailed it as a class C boat from Rockville. (Photograph courtesy of Dellie Eaton.)

SISTER DOTTERER. Leslie "Sister" Townsend Dotterer is the daughter of Mary Leslie Townsend Dotterer Jervey and Edwin Gaillard Dotterer. She has a brother, Gaillard "Gilly" Townsend Dotterer, who married Elizabeth Rembert Lacey. Sister married Donald Thropp Rutledge on June 6, 1964, and has two children. (Photograph courtesy of Jean Townsend.)

THE MORE THE MERRIER. This picture was taken during the 1952 Rockville Regatta. Friends would often spend the weekend, watch the races, and attend the nightly dances. These girls, from left to right, are (first row) Dellie Stevens and three unidentified friends; (back row) Mary King, Betsy LaRoche, Gusta Stevens, and one unidentified friend. (Photograph courtesy of Dellie Eaton.)

TWO BOYS ON THE ROCKS. Donald Rutledge sums up the feelings some old-timers have about this village by the sea, "Rockville—What a town! If you ain't been here, you ain't been nowhere, because that's precisely the location of this one-horse hamlet. This is the only place in the world where the people outnumber nothing else. You could put this whole town in the bow of the 'Undine' and still have enough room for a medium-sized mule. The village has no hotels, cabs, or movie theaters, and if you ask a native how to get to the drugstore, he'll go into convulsions with laughter. Things are so quiet and peaceful down here that ears are as worthless as a four-card flush. And if someone did speak to you there's no sense in listening because the brogue's so thick it's bulletproof. Down here the trees are old enough to grow fossils and life is so antiquated you'd expect to see dinosaurs in the pastures. The people are so way out, they're starting to come in backwards. Maybe that's why everyone loves Rockville. It's the last of an era, a part of our past. May it never change."

Index

Adams family members, 9
Allandale Plantation, 40, 41
Anderson family members, 6
Bailey, The Benjamin, House, 28
Bailey, Edward D., 21, 46
Bailey, The Edward D., House, 46, 95
Bailey, The Eleanor, House, 57
Bailey family members, 17, 20, 29, 51, 56, 57, 86, 89, 97
Bailey, the Joseph Pope, House, 106
Bailey, Osma, 20
Bailey, The Osma, House, 20, 28
Bailey, The Scott, House, 50
Barnwell, The Edward Henry, House, 57
Barton, Clara, 68
Batson, Annie Jenkins, 21, 57, 67, 76, 77, 86, 96, 97, 99
Beckett family members, 21
beach, 34, 86, 87
Bee family members, 6, 14
bench, 28, 40, 81, 86, 87, 114, 115
Bentz family members, 86
Bleak Hall, 36, 37, 43
Bohicket Creek, 4, 8, 9, 26, 30, 31, 44, 55, 107, 114
boll weevil, 7
Bolls, Kate McChesney, 32
Boykin family members, 59, 86, 98
Breakfast Creek, 7, 33, 78, 110, 111
Brigger Hill, 8, 52, 82
Bugby Plantation, 36
Bull, Elias Ball, 6, 11, 12, 14, 15, 20, 22
Cates family members, 56
causeway (see Linton family members)
chapel-of-ease, 7, 22, 66
Charles Town, 7
Cherry Hill, 92
Cherry Point, 8

Clark family members, 10
Cornish, John Hamilton Reverend, 8
cotton, 7, 10
Crane, W. T., 74, 75
Davis family members, 98
de Lasteyrie, Count Ferdinand, 84
Department of Agriculture, 43
Dotterer family members, 82, 124, 125
Duchess of Wadmalaw, 85, 92, 105, 115
Eaton, Lydelle "Dellie" Stevens, 6
Edisto Island Ferry Company, 9, 15
Edisto Island, 7, 10, 18, 36, 37, 42, 66, 69, 70, 76, 102
Episcopal rectory, 22, 23, 55
Evelyn, 119
Ferry House, 15
flag, 117
Fobbs, Alonzo, 92
Frampton, Elise Jenkins, 16
Frank Leslie's Illustrated Newspaper, 74, 75
Frasier, Christopher, 93
Fripp, The Charles E., House, 54, 55
Front Street, 9, 31, 32
Grace Chapel Road, 9
Grace Chapel, 66–72
Green, The, 7, 23, 24, 28, 80
Guest House, The, 99
Haiti, 43
Hall, The, 108–111
Hamilton, Paul, 7
Hurricane of 1893, 32, 34, 65, 68, 74
iron ore, 7, 126
Jenkins family members, 15, 16, 21, 30, 32, 36, 43, 57, 68, 76, 88
Jenkins, Anne Manson,
Jenkins, Batson, 86
Jenkins, Benjamin, 15, 16
Jenkins, Edward "Ned"

LaRoche Jenkins, 28, 30, 32, 33, 80
Jenkins, Sophia "Sophie" Augusta Seabrook, 2, 4, 6, 40, 42
Jenkins, The Joseph Wilson, House, 14
Jenkins, The Major Daniel Perry, House, 16, 28
Jenkins, The Micah, House, 15, 28
Jenkins, William Hamilton "Bill," 43, 54
King family members, 29, 95
kings of England, 7
LaRoche family members, 16, 45, 68, 70, 71, 79, 86, 110
LaRoche, Richard Jenkins, 110, 69, 70
LaRoche, The James, House, 21
LaRoche, The Joseph Edings, House, 32, 44, 45
LaRoche, Tahloulah Wilkinson, 90, 91
Legare family members, 104
Linton family members, 33
Lizzie Bee, 117
Louise, 111
malaria, 7
Mary Draper, 100, 104, 105
Matt II, 124
Maybank Highway, 9, 15,
McChesney family members, 88, 89
McChesney, Blanche Townsend, 77
McChesney, Rev. Paul Stanley, 48, 77, 79
McChesney, The Rev. Paul Stanley, House, 48
miasma (see malaria)
Mikell family members, 10
National Register of Historic Places, 6, 7
Native Americans, 7, 8
North Edisto River, 76
Orangeburg, South

127

Carolina, 27
Ordinance of Secession, 10, 36
Overseer's House, 52, 53
Paine, M., 4
Pecan Orchard, 55
Perry, Chester, 111
Perry, The Chester, House, 61, 111
Porter Military Academy "Porter's School," 43
postcard, 33
"Potter," Willie Simmons, 92
Presbyterian church (see Rockville Presbyterian Church)
Presbyterian Manse, 51
privy, 107
Proctor family members, 6, 60, 98
rectory (see St. John's Episcopal Church)
reunions, 81, 108, 109
Rivers family, 2, 78, 86, 93
Road to Rockville (see Maybank Highway)
Rockfarm, 8
Rockland Plantation, 30
Rocks Plantation, 7
Rocks, The, 7, 15
Rockville Presbyterian Church, 8, 65, 73–80
Rockville Regatta, 8, 113–125
Rockville, 7, 8, 9, 32, 33, 126
Roseville, 8
Rutledge, Donald, 126
Sams family members, 15, 68
Sandford, Lt. Col. Robert, 7
Schaffer, Ferdinand, 66
schools, 96–98
Scott family members, 22
Sea Island One Design, 119
Sea Island Yacht Club, 7, 110, 111
Sea Island Yacht Club Road, 9
Seabrook family members, 6, 10–12, 16, 33, 41–43, 64, 82, 83, 86
Seabrook Island, 10
Seabrook, George Washington, 10, 11, 64

Seabrook, Margaret "Peggy" Palmer, 6, 123
Seabrook, Mary Caroline Sosnowski, 2
Seabrook, Oliver "Ollie" Francis, 116, 122, 123
Seabrook, Oliver W., 96, 112
Seabrook, William of Edisto, 9, 15, 22
Simpson, Wallis, 85
Sosnowski family members, 10, 11, 38, 39, 40
Sosnowski, John Ferrars, 11
Sosnowski, The John Ferrars, House, 11
Sosnowski, The Joseph Stanislaus, House, 58
Sosnowski, Sophia "Sophie" Wentz, 38–40
St. John's Episcopal Church, 22, 23
Stevens family members, 16–19, 94, 103, 125
Stevens Line, 26, 106
Stevens, Agnes "Agie," 49, 91
Stevens, Daniel Augustus "Gussie," 49, 91, 101, 104, 105
Stevens, Capt. William Yates, 16, 17, 100
Stickney family members, 67, 86
stores, 9, 77, 99
Sunbeam, 103
Suggs family members, 95, 99
Surprise, 114
tabby, 7, 8
Taylor, Oliver and Sarah Ann, 14
Thomas, Bishop Albert, 22
Tiffany window, 68
Tolbert family members, 61, 62, 98, 102
Townsend family members, 30, 32, 36, 38, 39, 77, 78, 80, 82, 83, 86, 94, 95, 115, 116, 123, 124
Townsend, Daniel Jenkins, 30
Townsend, The Daniel Jenkins, House, 30, 31
Townsend, John Ferrars, 36, 37, 43, 72

Townsend, The John Ferrars, House, 32, 36–43
Townsend, Julius Charles, 99
Townsend, Walter, 118
Townsend's Boatyard, 106
Townsend's Overseer's House, 9
Tucker, Thomas, 15
U.S. Naval Academy, 68
Undines I–IV, 113, 118, 119, 122, 123
Wadmalaw Island PTA, 2
Wadmalaw Island Yacht Club, 122
Webb, The T. Ladson, House, 26, 27
Wedding Cake House, 24
Welsh's Lane, 9
Whaley family members, 12, 13, 61, 97, 116
Whaley, The Charles Grimball, House, 61
Whaley, The Hamilton Seabrook, House, 50
Whaley, The Henry Bailey, House, 12
Whitridge family members, 18, 20
Wilkinson family members, 90
Wilson family members, 22, 116
Wilson, The Edwin Bates, House, 24, 25
Wilson, The John C., House, 22
Wilson, The Joseph Jenkins, House, 14
Windmill, The Agnes W. Wilson, 23
yacht club (see Sea Island Yacht Club)
Yates, William, 16–18
Young, Rev. Thomas John, 22
Zeigler family members, 18, 19